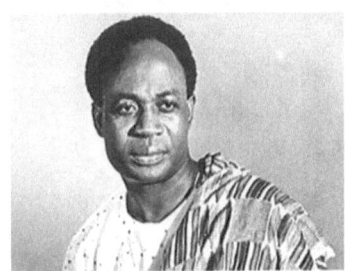

Dr. Kwame Nkrumah
First President of Ghana

THIRD WORLD TO FIRST WORLD— BY ONE TOUCH

Economic Repercussions of the Overthrow of Dr. Kwame Nkrumah

Author
Crusading Engineer
Robert Woode

Order this book online at www.trafford.com
or email orders@trafford.com

Most Trafford titles are also available at major online book retailers.

© Copyright 2011 Crusading Engineer Robert Woode.
All rights reserved. No part of this publication may be reproduced, stored in a retrieval system, or transmitted, in any form or by any means, electronic, mechanical, photocopying, recording, or otherwise, without the written prior permission of the author.

Printed in the United States of America.

ISBN: 978-1-4669-0454-5 (sc)
ISBN: 978-1-4669-0453-8 (hc)
ISBN: 978-1-4669-0455-2 (e)

Library of Congress Control Number: 2011960885

Trafford rev. 11/15/2011

 www.trafford.com

North America & international
toll-free: 1 888 232 4444 (USA & Canada)
phone: 250 383 6864 ♦ fax: 812 355 4082

CONTENTS

Acknowledgements ... 1
Preface .. 3
Introduction .. 9

CHAPTER I .. 11
CHAPTER II ... 31
CHAPTER III .. 35
APPENDIX I ... 37
CHAPTER IV .. 43
CHAPTER V ... 46
CHAPTER VI .. 53
CHAPTER VII .. 59
CHAPTER VIII ... 68
CHAPTER IX .. 87
CHAPTER X ... 104
CHAPTER XI .. 109
CHAPTER XII ... 115
CHAPTER XIII ... 120
CHAPTER XIV ... 123
CHAPTER XV .. 125
CHAPTER XVI ... 135

CHAPTER XVII	137
CHAPTER XVIII	139
CHAPTER XIX	143
CHAPTER XX	145
CHAPTER XXI	151
CHAPTER XXII	153
CHAPTER XXIII	160
CHAPTER XXIV	162
IN PURSUITE OF JUSTICE	177
Reference	187

Acknowledgements

I wish to show my greatest gratitude to the Good Lord above for granting me energy, even at this age of 74years, to write this book.

My thanks go to my sweet wife, Mrs. Juliana Woode, whom I have married for over 43 years without any major problems. I must congratulate her for tolerating my indiscipline—spreading books, magazines and papers all the time in the hall for her to "tidy" up; She together with the children—Mrs. Phyllis Nartey, Desmond and Kobina Woode for encouraging and supporting me.

Special thanks also go to my children, Stephen and Bryan in America who have been sending me vitamins for the upkeep of my health.

My computer secretary/typist, Johnny Fingerz (John Nortey), deserves special thanks for spending hours on end, searching for information on the net, typing, rearranging the subjects, editing and ensuring the printing of the draft copy in 2008 and working on the final copy in 2011.

I wish to thank Prof. Akosah for finding time, coming to my house and working on the draft copy.

I must also thank Prof. Kwabena Frimpong Boateng, for recommending me to present lectures organized by the Ghana Academy of Sciences on various topics. The decision to write the book partially emanates from the reaction of the audience after presenting some of these lectures.

Mr. Joe Adjei of J-Prompt, after reading the draft copy continuously reminded me of the need to upgrade the draft copy for him to serialize the book on the net. He also helped me to access

and import the special motors required to complete my Palm Tree / Pole Climbing Machine.

I must not forget Mr. Kojo Opong Nkrumah of Joy FM who hosted me on one of his morning shows when the draft copy was launched in 2008. The reaction of the audience also encouraged me to upgrade the book to its present form.

My thanks go to Mr. Larry Benson, formerly of Choice FM for his support. He was also present at the opening of Nkrumah Centenary Amusement Spot on the IPS road to film the rotating effigy of Dr. Kwame Nkrumah on top of the Ferries Wheel, as the latter was saying "Oh Ghana why are you going back? I'm turning in my grave."

Nana Kwesi Abra Samuel has been a good friend for many years. He provided first hand information on gestation period, yields, processing technologies for initial cracking of the almond, etc. I take this opportunity to congratulate him.

Despite his busy schedule, Mr. Francis Kwashie, formerly of Pioneer Tobacco Company, Takoradi, found time to proof read the draft.

Finally, I wish to thank Lt. Gen. Earskine, for intervening on behalf of those students who arrived early after the Coup to ensure that the Public Service Commission promptly interviewed them and had them employed by Government.

Preface

People write books for many reasons. I wrote this book because I am frustrated with my country.

Dear reader, 50 years ago (1961-2011) Ghana embarked on the Akosombo Hydropower Plant, we ran it, managed it, and carried out the maintenance activities. HOW COME that for a period spanning nearly two generations we never acquired the capacity to build the Bui Hydropower Plant, practically one quarter of the size of the Akosombo Plant with a much smaller lake and we are compelled to bring the Chinese to build for us? The question that beats me is this; would this have happened in Korea, India, or Malaysia under similar conditions?

Around the same period, we had the biggest Dry Dock in Africa (100,000 TONS), a petroleum refinery, boat yards, advanced engineering university and yet had to import the FPSO (Floating Production, Storage and Offloading).

(See diagram below)

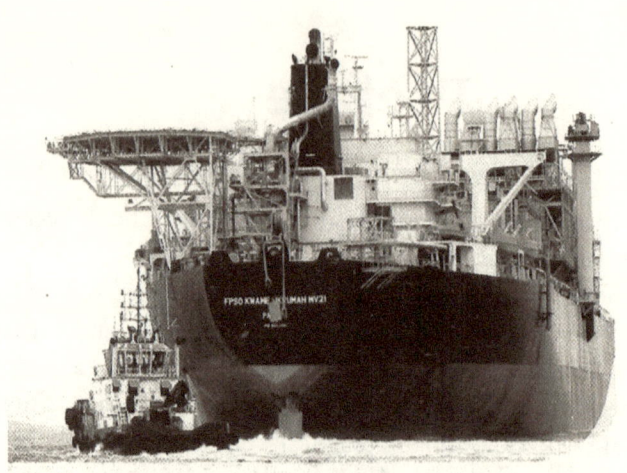

On the FPSO, oil is processed and separated from water and gas which may be present. The FPSO processes up to 120,000 barrels of oil per day and can store up to 1.6 million barrels in its tanks.
The FPSO is as large as 3 football pitches. Up to 120 people work and live on board the FPSO at any one time.

The FPSO is a floating ship or vessel as per the explanation above. One therefore requires a Dry Dock Facility to build it. Since it is a ship, one requires knowledge in boat building.

Finally, since it is a Petroleum Processing Plant, knowledge in petroleum refinery is absolutely necessary; having all this facilities in Ghana for nearly 50 years, in addition to Advance Engineering University (KNUST), we should have had the necessary empowerment to build the FPSO.

We had large vegetable oil mills, Gihoc Golden Oil Mill in Tamale, the Essiama Coconut Mill, etc. and yet we had to import a mill for shea butter in 2011.

In 1917, nearly 100 years ago, we had the Sese Palm Oil Mill in the Western Region, yet we had to import all the big Palm Oil Mills presently being used in the country. For nearly 100 years we could not create capacity to replicate a simple Palm Oil Mill.

We had a lift in 1924 at Korle bu, over 80 years ago, i.e. 2½ generations, yet we are unable to replicate it. Prof. Kwabena Frimpong Boateng called our attention to this. The question is what type of people are we?

In the fifties, cocoa was sold for £2000.00 per ton, that amount could buy 4vw cars. In the year 2011 cocoa is being sold for $3,000.00 per ton (£2000.00). But we require 10 tons of cocoa to buy one vw at $30,000.

The Volta River is discharging 20,000,000 liters of fresh water into the sea every 10 seconds, yet we don't have potable water in Accra, only a few miles from Akosombo, after 54 years of independence. This is why I am frustrated. Our people seem to be totally oblivious of these short comings.

We spend most of the time on Radio and TV discussing totally irrelevant issues while matters that are paramount to our survival are hardly discussed. Scarcely would one hear discussions on Science and Technology. We need to understand that the **"Poverty Gap is a 'Science and' Technology Gap."**

My frustrations emanate from the fact that one cedi (old cedi) was equivalent to one U.S. dollar when Dr. Kwame Nkrumah was overthrown in 1966. Presently (2011), one requires 15,000 old cedi to buy one U.S. dollar. In other words the cedi has lost 15,000 times its value or it has depreciated by 1.5 million percent in terms of the old cedis

Almost at the same period, one U.S. dollar was equivalent to over 300 JPY (Japanese Yen) (358 JPY to U.S. dollars 1971). Presently (09-2011) one U.S. dollar is equivalent to 76.8100 JPY. The Irony is that some people in our country are claiming that our economy has improved.

Our railway system including express rail, Accra, Kumasi, Takoradi, as well as intercity bus transport and internal air transportation system, i.e. between Accra, Kumasi, Sunyani, Takoradi and Tamale were intact in the sixties.

We had very reliable electricity and uninterrupted water supply in Accra. We were self sufficient in poultry product—eggs, chicken, turkey, guinea fowl, etc. There were practically no street boys and girls. There were no queues by young people at the embassies seeking to travel outside. Presently our best youth—in brain power and good health are all scrambling out. I can go on ad infinitum.

Unfortunately, those in political power seem to have no solutions. They are only explaining the problems instead of solving them.

A few years ago, at the onset of the fuel crisis, the American leadership decided to look seriously at alternative fuels, i.e. bio-diesel, ethanol, bio-gas, bio-mass, wind power, while the African leaders including our own were rather looking at increasing the price of the fuel as a solution.

In 1957-66, Kwame Nkrumah did not have a fraction of technocrats—doctors, engineers, architects, scientists, etc. and the greatest of all tools, **THE COMPUTER**. The internets, G.P.S, scanners, mobile phones, etc were not available. But let us see what he did.

At this juncture, I want to remind readers again that the $400,000,000 available in 1957 was generated by him through taxes on cocoa, rail travel, etc.

The real question is how come the Koreans and Malaysians, etc. managed to overtake us when they were behind us as at the time of the 1966 Coup?

We have barely managed to double cocoa production—500 thousand tons to one million tons in 50 years. Malaysia was producing a few thousand tons of palm oil around the same period (the 60s). In 1975 the Malaysia produced about 2million tons of palm oil but in 2009, Malaysia produced 17.7 million tons of palm oil. Their Palm Oil Research Institution has managed to obtain over 18 products from palm oil, how many products have we obtained from our cocoa research activities?

(See graph below: Malaysia's productivity has grown drastically over the past few decades)

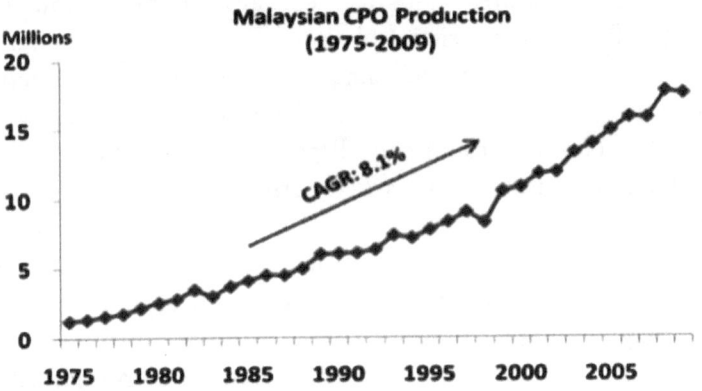

The Akans say, "If you can't carry your load you blame your head pad."

Ghanaians please wake up. I am sure readers do know now why I am frustrated!

My most disturbing frustration is the deliberate politicization of crime to avoid prosecution. The State is being looted through misappropriation of State Funds, Illegal acquisition of landed properties—land, vehicles and other assets. But anytime the issues are raised we politicize them and allow the culprits to get off the hook.

Finally it is now clear that the *COMMANDING HEIGHTS* of our economy are in the hands of foreigners. There is now the high probability of Ghanaians becoming slaves in their own country if we do not open our eyes.

Another disturbing problem is the unceremonial removal and displacement of public and civil servants from their posts at the onset of new administrations/governments. True, this problem has been with us since the overthrow of Dr. Kwame Nkrumah. The infamous "Apollo 568" that led to the dismissal of 568 public/civil servants during the Busia era, is an example.

When the AFRC (Armed Forces Revolutionary Council) came to power many young officers, some in their forties, were retired prematurely. This was a waste of human resource. When the PNDC (Provisional National Development Council) came to power some of Dr. Limann's body guards were kept in detention for as long as 7 years. I talked to some of them personally. The indiscriminate disposal of State Enterprises created similar injustices, as sacked personnel were deprived of their income without compensation. The cycle has been repeated as new governments are sworn in. Many honest Ghanaians have lost their positions for exposing corruption. A typical example is Mr. Hayford Appiah, former Ghana Telecom Chief Internal Auditor. As chief internal auditor, he exposed the corruption and outright stealing at Ghana Telecom and got sacked, during the NPP regime. Justice has failed him, despite the emblem "Freedom & Justice" on the National Crest. 71 public servants from ADB (Agricultural Development Bank) including top young brains lost their jobs because they were perceived to be in opposition political party. Some including Mr. J.S. Cooke, could not contain the shock and died.

The National Reconciliation Commission was not designed to solve the problems mentioned here. Many Ghanaians are hurting inside and crying, as a result of emotional and financial difficulties. This is not morally good for our Nation.

We need to reduce the unlimited power given to political leadership because it is obvious that most political leaders are failing to exercise circumspection in handling appointments.

The solution is to strengthen the Public Service Commission to empower them employ people to specialized positions through meticulous interviews for clearly defined assignments in consonance with the National Development Agenda. Meticulously prepared terms of reference must be available to help determine the criteria for evaluating performance of such public servants. Recommendation for removal of public /civil servants must be presented to the Public Service Commission for proper investigations and determination of guilt/non performance.

Introduction

Majority of young people are totally unaware of the projects that were undertaken by Dr. Kwame Nkrumah in the sixties and therefore cannot appreciate the economic repercussions of their truncation. The Coup took place in 1966, i.e. 45 years ago. It is fair to assume that anyone who is less than 55 years could not fully appreciate Dr. Nkrumah's contribution to the economy without being informed.

We need to be conversant with where we are coming from before we can determine where we are going.

Nkrumah's detractors try to create the impression that his projects failed due to mismanagement. My position is that the projects were truncated. It is important to note that almost all the projects—oil refinery, atomic energy, state farms corporation, etc. were launched in 1963.

The Coup took place in Feb. 1966, in other words, the projects went through a 2-3years gestation period only! How could such projects declare profits and therefore be deemed inefficient and therefore deserve truncation?

To blame Nkrumah for the collapse of the State Enterprises is to say the least dishonest. Readers must understand that apart from the U.S. almost all the States in Europe and elsewhere had used State Enterprises system as a 1st step to build their economy. In fact, until Margaret Thatcher of Great Britain came to power the commanding heights of British Economy were in State hands; these included British Steel, The Mines, Telecom, Water, Gas, Aircraft Manufacturing, etc. To ensure proper management of the projects, Dr. Nkrumah had sent hundreds of Ghanaians to the Eastern countries to acquire the necessary Scientific and Technology

Empowerment. The Coup prevented most of the people from coming back because of intimidation.

The book gives a short history of Dr. Nkrumah's vision, summary of some of his projects, the economic situation in Ghana before independence, the number of educational institutions and industries. It also describes those conditions that led to the introduction of the PDA and describes those conditions that led to the overthrow of Dr. Busia's government as well as a summary of Acheampong's rule.

The book also examines the capacity of the private sector in the 21st Century to create wealth; the parameters of the value addition chain as well as the dynamics of wealth creation in the 21st Century and their relevance to our present situation.

It also recommends the way forward, the energy situation and processing our Crude Oil into various products in order to spread the wealth base and to prevent the oil curse. It emphasizes the need to establish Machine Building Capacity so that we can manufacture all the things that we need since the Poverty Gap is a Technology Gap.

It also emphasizes the use of Scientific Institutions as trainer of trainees to empower the youth to acquire knowledge, technology and financial power. It proves that Kwame Nkrumah was doing exactly what the Chinese were doing to bring their Nation to the present state. The success of the Chinese has vindicated Dr. Kwame Nkrumah with respect to his methods for turning or improving the economy of Ghana.

Finally, it talks about the quality of leadership required to meet our developmental challengers. The last pages are devoted to the Author's activities. I believe it will be useful for the youth and all politicians to critically analyze the suggestions and recommendations made by the Author.

CHAPTER I

Economic Repercussions of the Overthrow of Dr. Kwame Nkrumah in 1966

Dr. Nkrumah's Short History:

Dr. Kwame Nkrumah (1909-1972) was the first Prime Minister (1957-1960) and President (1960-1966) of Ghana. He was also the first post colonial black African leader if you discount President Tolbert of Liberia, and Haile Salassie of Ethiopia.

An influential 20th century advocate of Pan-Africanism, he was a founding member of the Organization of African Unity and was the winner of the Lenin Peace Prize in 1963.

Over his lifetime, Nkrumah was awarded Honorary Doctorate Degrees by Lincoln University, Moscow State University; Cairo University in Cairo, Egypt; Jagiellonian University in Kraków, Poland; Humboldt University in the former East Berlin; and many other universities.

In 2000, he was voted Africa's man of the millennium by listeners to the BBC World Service.

Works by Kwame Nkrumah

- "Negro History: European Government in Africa," *The Lincolnian*, 12 April 1938, p. 2 (Lincoln University, Pennsylvania)—see Special Collections and Archives, Lincoln University

- *Ghana: The Autobiography of Kwame Nkrumah* (1957) ISBN 0-901787-60-4
- *Africa Must Unite* (1963) ISBN 0-901787-13-2
- *African Personality* (1963)
- *Neo-Colonialism: the Last Stage of Imperialism* (1965) ISBN 0-901787-23-X
- *Axioms of Kwame Nkrumah* (1967) ISBN 0-901787-54-X
- *African Socialism Revisited* (1967)
- *Voice From Conakry* (1967) ISBN 90-17-87027-3
- *Dark Days in Ghana* (1968) ISBN 0-7178-0046-6
- *Handbook of Revolutionary Warfare* (1968)—first introduction of Pan-African pellet compass ISBN 0-7178-0226-4
- *Consciencism: Philosophy and Ideology for De-Colonisation* (1970) ISBN 0-901787-11-6
- *Class Struggle in Africa* (1970) ISBN 0-901787-12-4
- *The Struggle Continues* (1973) ISBN 0-901787-41-8
- *I Speak of Freedom* (1973) ISBN 0-901787-14-0
- *Revolutionary Path* (1973) ISBN 0-901787-22-1

Dr. Nkrumah was overthrown in a military Coup in 1966. The CIA of America has since admitted in a declassified document that they masterminded the Coup.

While studying in the United States at the Lincoln University in Pennsylvania around 1935, he was influenced by the writings of Karl Marx, Friedrich Engels and Vladimir Lenin. He actively supported the African Liberation Movement through various advocacy programmes and activities and was elected President of the African Students Organization of America and Canada. As an undergraduate at Lincoln he participated in at least one student theater production and published an essay on "European government in Africa" in the student newspaper, *The Lincolnian*.[6]

In 1947 Dr. Nkrumah returned to the Gold Coast on the invitation of the United Gold Coast Convention (UGCC) a nationalist party formed by Dr. JB Danquah, Paa Willie and others to liberate the then Gold Coast from colonial rule. [7] This political convention was exploring paths to independence. Nkrumah accepted the invitation and sailed for the Gold Coast.

He split from the UGCC in 1948 and formed the CPP because he felt the UGCC was too conservative in their tactics.

He suffered two imprisonments 1948 and 1950 under the British Colonial Government.

In 1951 he led the CPP into general election and won massively and became leader of Government Business.

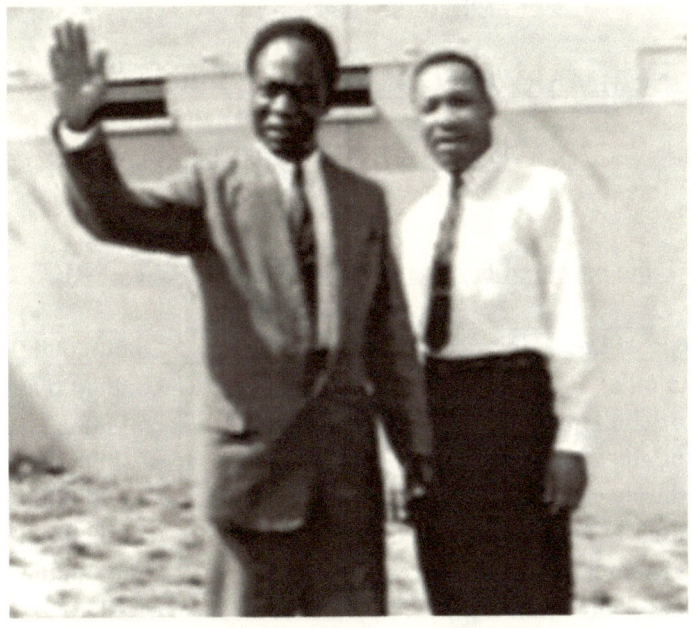

Dr. Kwame Nkrumah and Dr. Martin Luther King, Jnr.

As a leader of this government, Nkrumah faced many challenges: first, to learn to govern; second, to unify the Gold Coast; third, to win his nation's complete independence from the United Kingdom.

Nkrumah was successful at all three goals. Within six years of his release from prison, he was the leader of an independent nation.

He became the first Prime Minister of Ghana when the country gained independence in 1957. He was hailed as the **Osagyefo**—which means "redeemer" in the Twi language.

In 1960 Ghana became a Republic and changed his status to President.

Between 1961 and 1966 Dr. Nkrumah spearheaded an ambitious hydroelectric project on the Volta River, built a new harbour and township at Tema, as well as many industrial projects and large agricultural plantations and other projects listed in subsequent paragraphs.

(Please see table below)

SUMMARY OF COMPLETED PROJECTS IN GHANA FROM 1961-1966

Table prepared by, James Butler-Aggrey, M.Sc., FRICS

Project	Cost
-Peduasi Lodge (Nkrumah's Palace)	£6,000,000.00
-Job 600	£8,000,000.00
-Korlebu Hospital Extensions	£5,000,000.00
-Korlebu Lagoon Bridge	£2,500,000.00
-Atlantic Hotel	£2,000,000.00
-Kumasi City Hotel	£4,000,000.00
-New Bank of Ghana	£4,500,000.00
-New Commercial Bank	£4,200,000.00
-Jute Factory	£1,500,000.00
-Cocoa Silo at Tema	£8,500,000.00
-College of Administration	£800,000.00
-Army Barracks—Tema	£2,500,000.00
-Army Barracks—Sunyani	£3,500,000.00
-Tamale Air Field	£13,000,000.00

-Army Officers Bungalows—Burma Camp	£4,500,000.00
-Air Force Quarters on the way to Burma Camp	£2,500,000.00
-YWCA	£1,500,000.00
-New Government Transport—Kumasi	£2,000,000.00
-New Government Transport—Accra	£2,000,000.00
-Black Star Square	£3,500,000.00
-Block of Flats for Volta River Authority	£4,000,000.00
-High Rise Office Blocks for the Income Tax	£2,500,000.00
-Museum in Accra	£3,000,000.00
-New Police Headquarters	£2,000,000.00
-Prison Warden Quarters	£2,000,000.00
-Police Quarters at Tesano, Airport and Mamprobi	£3,500,000.00
-New Judges Bungalows	£4,000,000.00
-New Animal Husbandry at Larbi	£3,500,000.00
-Star Hotel	£5,000,000.00
Printing Press at Tema	£3,000,000.00
TOTAL	£114,500,000.00

The above list does not include major ongoing projects that were not completed, e.g. the petroleum refinery at Tema, the dry dock, the 22,000 acre rubber, the Gold Refinery at Takwa, and many major projects such as the Akosombo Hydropower Plant Station and the State Housing Projects.

For those who constantly insist that Kwame Nkrumah "Chopped Money" will have to revise their notes after going through this. The $400,000,000.00 many people cite as having been left by the colonial government was actually generated by Dr. Kwame Nkrumah from levis and taxes on timber, minerals, cocoa and the railway service.

There were at least 8 attempts on his life—Dodowa Vilas, Railway Station Annex, UAC Motors, Accra Stadium, Kumasi Assembly Hall, Flag Staff House, and Kulengugu and around the main ministries. In a reaction to these attacks, Nkrumah said, *"THE*

BOMB WAS NOT AIMED AT ME AS KWAME NKRUMAH, BUT THROUGH ME, AT GHANA AND THE REST OF AFRICA. AS FAR AS I AM CONERNED I AM HAPPY IN THE KNOWLEDGE THAT DEATH CAN NEVER EXTINGUISH THE TORCH WHICH I HAVE LIT IN GHANA. LONG AFTER I AM DEAD AND GONE, IT WILL CONTINUE TO BURN AND BE BORNE ALOFT, GIVING LIGHT AND GUIDANCE TO THE PEOPLE."

These attempts together with other agitations against his development programmes totally upset him, e.g. Tema Harbour was resisted, Akosombo Dam was resisted, and Tema Motor way was also resisted. He had to adopt strong measures including the PDA (Preventive Detention Act) to allow him hold on to power to achieve his vision for the country.

It is obvious that his inability to supervise the application of the PDA (law) created room for serious abuse by third parties which gave pretext to his detractors to join forces with the CIA to overthrow his regime. The CIA believed Nkrumah was taking Ghana and subsequently Africa to the Eastern Block. Nkrumah was a victim of the ideological war between the Americans and the Soviet Union (Capitalism vs. Communism). The Military Government—NLC (National Liberation Council) led by General Ankrah directly succeeded the CPP in 1966.

GOLD COAST AT A GLANCE

SECONDARY SCHOOLS:	Very few
CAPE COAST:	Mfanstipim, Adisadel, St. Augustine, Holy Child, Wesley
ACCRA:	Achimota Sch., Accra Academy, (6th Form) in Accra Academy. Odorgono Sec. Sch.

KUMASI:	Prempeh College, Opoku Ware (6th form Science and Arts alternated annually), Maximum students 10 for Science Students.
HO:	Mawuli Secondary 6th form
UNIVERSITY OF LEGON:	Arts, Maths. Physics

INDUSTRIES:

ACCRA: Accra Brewery, Chrystal Oil Mills, Pomade Factory, AG Seward, Toffee Factory (UAC) Dorman Long (Steel Fabrication)

KUMASI: Nasser Pioneer Biscuit, some few Timber Mills, Two soft drink factories, one rice mill and Tusker cigarette factory which was later moved to Takoradi.

OTHERS: Miscellaneous mines, Sese Oil Mill, Timber Plywood. L-Rose Lime Juice, Asebu.

MAIN EXPORT: Cocoa, Gold, Timber, Bauxite, Manganese, Palm Oil, and Palm Kernels from wild grooves.

RAILWAYS: Main Revenue for Government

SHOPS: U.T.C. U.A.C. G.B. Olivant, SCOA,CFOA, Indian Emporium

BANKS: Standard, Barclays

MAIN HARBOUR: Takoradi

POWER SOURCE: Small Diesel Generators and some Steam Generators

POPULATION: about 4.5 million per capital $400

Total Foreign Reserves: $400 million

% Literacy: Estimate—2-%

KWAME NKRUMAH'S VISION

"And across the parapet I see mother of Africa, Her body smeared with the blood of her sons and daughters in her struggle to set her free from the shackles of Imperialism . . . I hear and see the springing up cities of Ghana becoming the metropolis of Art, Science and Industry, Scientific Agriculture Philosophy and learning."

With this vision he embarked on the accelerated development of Ghana on the following path:-

1. Many Second Cycle Schools were built under special scheme. Ghana Education Trust, Technical Institutions and Trade Schools as well as universities, (UST, Cape Coast and projected Agricultural University in the Volta Region that never took off.)
2. The Ghana Academy of Science or the present Council for Scientific and Industrial Research (CSIR) was established.
3. Ghana Atomic Energy Commission was founded and the 1st Atomic Reactor in Africa was embarked upon.
4. An area around Otunshie, the present site of the Industrial Research Institute was acquired for the purpose of a science city.
5. To promote medicine (both orthodox and unorthodox) the medical school was established, concurrently with the Centre for Herbal Medicine.
6. Arts and Culture were not left out so Ghana Film Industry was established.

DR. KWAME NKRUMAH ON SCIENCE AND TECHNOLOGY

"It is within the possibility of science and technology to make even the Sahara bloom into a vast field with verdant vegetations for agricultural and industrial developments.

We shall harness radio, television, giant printing presses to lift our people from the dark recesses of illiteracy. This is the age in which science has transcended the limits of a physical world and technology has invaded the silences of nature. Time and space have been reduced to unimportant abstractions. Giant machines make roads, clear forests, dig dams, lay out aerodromes. Monster trucks and planes distribute goods, huge laboratories manufacture drugs, and complicated geological surveys are made etc. all at incredible speed The world is no more moving through bush paths or on camels and donkeys. We cannot afford to pace our needs, our development, our security to the gait of camels and donkeys This is because we have emerged in the age of science and technology in which poverty, ignorance and diseases are no longer the masters, but the retreating foes of mankind" (Kwame Nkrumah May 24, 1963) O.A.U. Conference.

Extracted by,
Robert Woode, alias Crusading Engineer, March, 2011.

ESTABLISHMENT OF INDUSTRIES

Dr. Kwame Nkrumah was aware that capitalism could not be practiced without capital. Successful capitalism required Banking Systems, Management Skills, Knowledge and Technology which our people did not have. Therefore in consonance with the prevailing trend in the developed world, he set up a number of well-planned integrated industries including the following:-

a. Cocoa processing for value addition and supported by the Cocoa Research Institute
b. Glass Manufacturing
c. Ceramics, Tiles & Terrazzo, Marble Art
d. Pre-fabricated Building Panels, bricks and tiles to support housing programmes through the State Housing Corp.
e. Meat processing, leather, shoe, glue and rubber/tire manufacturing

f. Steel works to be supported by Oppong Manso Iron Ore
g. Textiles & Garment supported by large cotton farms, Zongo Macheri (1000 acres. etc.)
h. Sugar Production
i. Jute bags manufacturing for cocoa
j. Food complex for miscellaneous food production, flour, fish, feed, etc.
k. Match Factory, Paper Conversion Factory and electronics including fridges
l. Akosombo Power Plant and Valco smelter
m. Cement Works
n. Distillation Plants and Fruit Cannery.

COMMUNICATION AND TRANSPORT

He built a new harbor at Tema, created reliable intercity and West African transport system with State Transport Buses, Ghana Airways (operating from new Accra Airport) and Black Star Lines (operating worldwide) supported by the only Dry Dock on the West Coast. He put up interconnecting telephone network with the aid of the Canadians. River Transport Yapei Queen and extended rail system—the Blue Train should not be forgotten. An all electric line (Accra-Tema) was planned.

He used foreign contractors to build the Tema Motorway and the Adome Bridge and local indigenous contractors S.C.C. to build an internal road system, bridges and high rise building including the famous Job 600. A well equipped machine shop in Accra was established to give technical support to the fleet of road building machines used by the S.C.C. which was even encouraged to take contracts outside Ghana just as the Chinese are doing now.

SOME MAJOR PROJECTS

I still believe that Dr. Nkrumah's greatest contribution to the economy of this country was in agriculture. The 22,000 acre rubber plantation in the Western Region of Ghana established within 5

years was a world record. The final area targeted for plantation was 75,000 acres; the biggest rubber plantation in Africa other than the Firestone Rubber in Liberia (100,000 acres). We assert that with an economic life exceeding 70 years the 22,000 acre rubber plantation had full capacity to pay for all the debt Nkrumah was supported to have left. Any one doubting this can compute from the yield of rubber latex per acre per year multiplied by the world price of latex per kilo.

Dr. Nkrumah's Government invested in large scale Palm Oil Plantation, Cola, Coconut, Cotton, Sugar Cane, etc. using the State Farms Corporation which set up 104 farms. The biggest poultry farm in Africa was established at Akoko Photo, Odorkor. The biggest cotton farm on the West Coast was established at Zongo Macheri 1000 acres. Kenaf farms were established in Ashanti and Brong Ahafo to supply material for the Jute Factory in Kumasi.

Cattle farms were established in the Volta Region because it had two rainy seasons as against one rainy season in the North.

Large scale artificial insemination programme was embarked upon at Ohawu/Tadzewu for improved cattle production with the help of Israeli specialists.

In fact my office then at the State Farms Corporation was in charge of the importation of the vile from Canada. Over 1000 herd of cattle from this stock was kept at Kwamoso and the whole herd disappeared when the PNDC Government took over the project.

Two large scale sugar cane plantation supported by out grower schemes were established at Komenda and Asutware. One needs the whole day to table the projects. But having given you the idea of the state of the economy, i.e. Vis a Vis the number of industries we had before Dr. Nkrumah took over the country, you would appreciate the enormous leap into real industrialization.

FAILURE OF PROJECTS

1. The guidelines for managing the national economy were in the G.O. General Orders-principally: a Law and Order document not designed to support production

and industrialization. The document was designed by the British to assist in the administration of the colony. Strictly to maintain Law and Order in the Colony.
2. National Budget was effective from July when farming season commenced in Feb/March. This greatly disturbed farming programmes.
3. Manpower Requirement: Project managers not sufficiently knowledgeable to run state enterprises.
4. Misunderstanding of ownership of state enterprises
5. Lack of commitment by leadership.
6. An un-empowered non-development oriented civil/public servant whose main orientation was in the maintenance of the "Status Quo"—i.e. to support law and order on behalf of the colonial government.

It is common knowledge that the State was the largest employer and public and civil servants were required to perform many services that compelled them to travel around.

Public/Civil Servants in those days travelled in State busses, Trains and airlines by presenting "warrants" those warrants—credit vouchers that were supposed to be redeemed for cash from the consolidated funds. Unfortunately, this scarcely happened. Civil/Public Servants stayed in State hotels/guests houses without settling bills after they have gained entry into those hotels with letters from Sister State Organization.

State organizations received fuel and lubricants from Goil, the National Petroleum Company, and no serious attempt were made to settle the bills. State organization never paid for telephone, electricity and water as well as rents from the State Housing Company. The State farms supplied food items including—rice, maize, vegetable oils and fruits to the castle which were never paid for. This misunderstand of ownership of State of Enterprises totally undermined financial institutions of the enterprises. It bred indiscipline and gave room for diversion of state resources into private pockets.

To overcome some of the challenges Nkrumah set up the Ideological Institute for re-orientation and sent large number of students to study in the Eastern Countries.

Unfortunately, the Coup took place just when those students, empowered in Science and Technology, were returning in 1966. The Coup makers also withdrew a lot of students from the Eastern Countries. The fear was that the students would be contaminated with communism and as a result of the antagonistic pose of the Government then, most of these students went elsewhere.

Yes if the Coup had delayed one year Ghana would have been a totally different place now.

THE INTRODUCTION OF THE P.D.A.

(PREVENTIVE DETENTION ACT)

CONDITIONS PRECEDENT:

Critics of Dr. Kwame Nkrumah often cite the P.D.A. as an instrument of oppression brought by him to terrorize the opposition.

The writer asserts that PDA was introduced in response to the exigencies of the situation at the time.

It is obvious that the main interest of the opposition was to create ungovernable conditions.

The NLM (National Liberation Movement) was the main party in opposition to the CPP and its motto was **"mate me ho"**—separation from Ghana.

In 1954 it embarked on a series of terrorist activities, including the following:-

Attacks on CPP owned buildings, Burning of CPP vehicles, Physical attacks on CPP supporters, etc.

Arson of CPP Propaganda Vans:

The writer was an eye witness to this event. I lived in house number NTER 132. This was on the last road parallel to the road bounded on the south of the Jackson Park. This parallel road leads to the Anglican School and to the Government Boys School. I was standing on the T-Junction of the road in front of NTER 132 and the main Asafo-Jackson park road, almost in front of Asem Hene's house. I was about to cross the main road to enter the road leading to INTER 132 when I saw the CPP van, a Peugeot 203 being chased by an NLM van also a Peugeot 203 coming from Asafo towards Jackson Park.

Kumasi in those days was a small place so many people knew each other. I recognized the driver of the CPP van as Mr. Kofi Agyekum who lived at NTER 22 not too far from my mother's house NTER 5. I had seen the two vehicles as they came from Asafo side about 300 meters which was an incline towards the Jackson Park. The NLM car was newer and managed to overtake the CPP vehicle at the T. Junction. The occupants of the CPP vehicle jumped out and ran for their lives. The men from the NLM van broke the windscreen of the CPP van, poured petrol on it and set it on fire. After burning for a while, the car started reversing because of the incline and got trapped by the gutter almost in front of Asem Hene's Palace. The situation in Kumasi was such that it would have been suicidal to give evidence in court!

Another CPP van was also chased at Akwatia line and burnt, the driver was Mr. Bossman staying at Krofufrom. He was later employed as a bus driver at the KMC (Kumasi Municipal Council) when Mr. B.E. Dwira was appointed KMA Chairman after independence in 1957. Both burnt vehicles were Peugeot 203 caravans and were black in colour.

Attacks on CPP Supporter's Buildings:

Many houses belonging to CPP sympathizers were dynamited. One Mr. J.T. McCauley leased his house at Dadiesoaba to one Dr.

T.E.B. Awuku, a practicing medical officer and a supporter of the CPP. This house was also dynamited. Mr. B.E. Dwumo's house at Krofufrom popularly known as CPC was also dynamited. Mr. Attah Mensah who later became the first director of the Ghana State Farms Corp house was also dynamited.

Mr. Adjei Kwame's house at Ash town main road was blown up near the Subin Valley.

A CPP printing press the "Sentinel" was blasted near Manprong Hene's house on the Ash-town main road. Naja David's house where Mr. James Owusu was staying was also blown up.

I have no record of any property belonging to any NLM supporter that was dynamited, and will be very grateful to receive any information contrary to my assertion.

The CPP attacked one Land Rover belonging to the NLM. The vehicle was overturned but never set on fire.

Dr. Nkrumah took steps to neutralize CPP thugs engaged in negative activities. Mr. Kofi Smith, Owuo, Antwi and one Teacher who were notorious for illegally collecting items from Lebanese and Indian shops in Kumasi were detained under the P.D.A.

I employed Owuo as a low loader driver at the State Farms after his release from detention in 1966. I had to sack him after about three years due to his indisciplined character.

I have heard many critics of Dr. Nkrumah insisting that the rule of law should have been allowed to work.

The situation in those days could not have allowed this to happen. It is important to remember that similar ungovernable situations existed in most places in the country.

The Ga Shifomopkee were saying that "Ga shipong Ga maa nog" meaning Ga land belongs to Ga people and that non Ga persons must leave Accra.

The Northern Peoples Party was agitating for the separation of the Northern Territories, and "Ablade" of the Volta Region were asking for separation. All these groups were resorting to violence. The P.D.A acted as a great deterrent to prevent Ghana from disintegrating. People became totally law abiding because of the P.D.A. I assert with all the power at my disposal that the P.D.A.

saved Ghana. Dr. Kwame Nkrumah must be praised for his firmness. This is not to say that the P.D.A was not abused by unscrupulous people.

I always remember the story of Dr. Owusu of Astek. He narrated to me of how he was accosted by a senior police officer on the Weija Road before the then Odorkor Police Barrier when he was coming to Accra in his VW car with his girl friend and her girl-friend friend. Somewhere around the now Malam Junction, he was stopped by a Senior Police Officer who was the boy friend of his girl friend's friend in his car. The Senior Police Officer wanted his girl friend in the company of Dr. Owusu's girl friend to alight and join him. Somehow this girl friend refused.

As if fate would have it, Dr. Owusu's VW broke down and had to be abandoned. He reached home by Taxi. The girl friend's friend later went home to her Senior Police Officer.

Early the next morning, the senior policeman's girl friend paid a visit to Dr. Owusu's house and expressed great surprise at seeing Dr. Owusu, why because according to her the senior police officer had left instructions at the police Barrier for the arrest and detention of Dr. Owusu if his VW reached the Barrier. It appears the senior officer had become offended because he felt Dr. Owusu should have practically ejected the girl to join him. Dr. Owusu was saved by FATE that is the breakdown of his VW. Of course Dr. Kwame Nkrumah would have been blamed for the detection of an innocent person.

I recall my own personal experience during the PNDC when there was an announcement urging driver/owner of Mercedes Benz, car No. GN 4309 to report at the State House. I was the owner and driver of that vehicle, so I had to report. I was on my farm at Adum Banso in the Western Region when I had the information. Of course everybody knew that if you were called then, it meant arrest and possible seizure of property. Somehow, I was not perturbed because I had kept a low profile and had not been involved in any activities that could be construed as anti-government, be it corruption, stealing, etc.

On arriving from Adum Banso at the weekend, I decided to track the office that had issued the order. I went to the State House and was directed to Mr. Kwamena Ahoi's office. I was with my wife. As soon as I entered the office, I saw Mr. Kwamena Ahoi holding a big gun, possibly an AK 47. He then asked me to bring my Mercedes Benz, I asked for the reason, and he told me that I had addressed students. I was shocked and insisted that it might be a mistaken identity because I had not addressed any students. In fact, I had even forgotten that tertiary institutions, including Legon, had been closed and the PDC had occupied the Legon campus. He insisted he was going to bring witnesses to identify me but that it would be in my interest to admit. But how could I admit something I had no knowledge of? I managed to track his elder brother Atto Ahoi who lived nearby, on the 4th Circular road, because we were always attending Talking Point together. To cut a long story short, he prevailed on his brother not to take the vehicle from me. But what was my offence? I discovered that two weeks earlier, I was passing from Achimota through Legon to Madina. I remember a group of young men stopping me for a lift. I had just reached the faculty of Agriculture. From my mirror, I discovered that the people appeared drunk from their gait, so I moved off. That was my offence.

They were CDRs and PDCs who had occupied Legon. They took my number and framed a charge against me. For refusing to give a lift to a group of drunk looking guys, I was going to literally lose a virtually new Mercedes Benz 240 D that had caused me years of very hard work to acquire!

The lesson is that we should all fight for the RULE OF LAW. We should always trust our freedoms into Institutions not in individuals.

Ghanaians should never allow dictatorship under any guise in this country. Unscrupulous people always take advantage to enrich themselves.

Because of human nature, Dr. Kwame Nkrumah should have set up a REVOLVING COMMITTEE OF EMINENT GHANAIANS TO CONTINUOUSLY REVIEW THE CHARGES AGAINST

THE DETAINEES. This would certainly have reduced the incidence of innocent people who found themselves in detention.

The State should then prosecute people who made up stories to put other people in detention. I advocate for a revolving committee to prevent the committee becoming corrupted.

In any case, I have no doubt in my mind that this country would have disintegrated had it not been for the fear of PDA. I was a grown up in those days and absolutely understood the forces at play in those days.

GEOPOLITICAL SITUATION IN THE WORLD

1945-1966

HOW DR. NKRUMAH WAS AFFECTEED:

At the end of the 2^{nd} World War the world had become totally polarized into East and West.

The powerful Soviet Forces reached Berlin first and all the countries lying between the then USSR and Berlin became Satellite Countries of USSR. Germany was divided into four—The British, The Americans and The French-owned what was called West Germany and The Russians owned the Eastern part later called East Germany. Berlin the Capital of Nazi Germany which then lay totally within East German territory became an "Island" occupied by Nato Troops and the Soviet Forces. Berlin was therefore divided into East and West, with the East Berlin owned by the Soviet Forces and the West Berlin owned by the Nato Forces.

Even though there was collaboration between the Western Alliance (America, Britain and France) and the Soviet Union, during the war, the situation changed dramatically after the war. A dangerous "Cold War" developed between the two sides, resulting in the establishment of War Camps—The NATO Forces and the Warsaw Pack Forces. The Warsaw Pact Forces were made up of countries east of Berlin. The relationship between the East and the West was based on "your enemy's enemy is my friend." This was

the reason why the Soviet Union supported North Korea when the Americans supported South Korea. It is the same reason why the Americans supported anti Russian Forces in Afghanistan, and why the Soviet Union supported Egypt during the proxy war between Egypt and Israel.

The rift between East and West was so bad that even when friendly talks were being held, spy planes were flying everywhere. In 1956, even as friendly meetings were taking place between East and West the Americans sent a high altitude plane "the U2" into Soviet territory to spy. It was believed at that time that no weapon could bring down a "U2." The Americans were shocked when a Soviet SAM (Surface to air Missile) brought down the U2. Relations were so bad that it was dangerous to be found with a Soviet Visa in your passport. The Soviet Union resorted to insertion visa to protect visitors to the USSR. The writer had an insertion Visa throughout his stay in the USSR in the early sixties.

Dr. Kwame Nkrumah had good personal relationship with Nikita Krushev, the Soviet Leader, and this relationship culminated in a visit to the USSR in 1961. The Soviet Union and the Eastern block decided to offer 3000 scholarships to Ghanaian students to study in tertiary institutions in the Eastern Countries. This did not go well with America and its allies. The Soviet Union decided to build the Bui Dam to counter the building of Akosumbo by the Americans. Many Soviet supported projects were being undertaken in Ghana in those days.

The Eastern Countries supported projects such as the Shoe Factory, the Aveyime Tannary, the Sugar Factory, the Tomato Processing Factory and many others.

In the eyes of the Western Powers, Dr. Nkrumah was becoming the "friend" of the "Enemy". Furthermore, Nkrumah's influence in Africa was great and the fear was that Africa, the source of cheap raw materials for the West as well as the market for Western goods was slipping away under Nkrumah's leadership so he must be stopped.

The West found local allies in Ghana. Clandestine Propaganda were around that Ghana would become a communist country where the citizens would wear one type of cloth, eat from large cooking

pots where no one would have a choice as what to eat, creating a lot of panic within the society.

I request the youth to ask their elderly relatives about this. The truth is that Nkrumah wanted to take political advantage of the ideological differences between the West and the East, to build this country. In fact, Indira Ghandi did that for India. As a result of her strategy the Soviets built almost all the heavy industrial base—steel works, cement, engineering infrastructure in India during the cold war period as the Americans provided financial aid for other needs of India.

Dr. Nkrumah tried to beat off the communist tag by joining the Non-Aligned Movement. Prominent among the movement were Tito of Yugoslavia, Nasser of Egypt, Indira Ghandi of India and Haile Selassie of Ethiopia.

Under Nkrumah, private enterprises, state companies and multinational companies functioned without any conflict.

Many large state projects were taking place simultaneously—major road construction (Tema Motorway), Housing Development, Steel Works Universities—all demanded large financial outlay. These projects did not stall because he was being wooed by both the East and West. He always managed to get funding at the more critical time from either the West or the East.

His 7 year development program was derailed when cocoa price went as low as £600.00 from nearly £2000 per ton.

The irony is that Dr. Nkrumah had chosen exactly the same path that the Chinese had taken to reach where they are now. It will be recalled that China experienced the same shortages of so called essential commodities during its developmental transition.

CHAPTER II

THE COLLAPSE OF THE ECONOMY:

Information at our disposal indicates that as at 1966 Ghana's economy was still stronger than that of South Korea.

(See Graph 1.1)
<Graph 1.1> Trends of GNI per Capita per Capita Growth in Ghana, Korea and Malaysia.
(1962-2006)

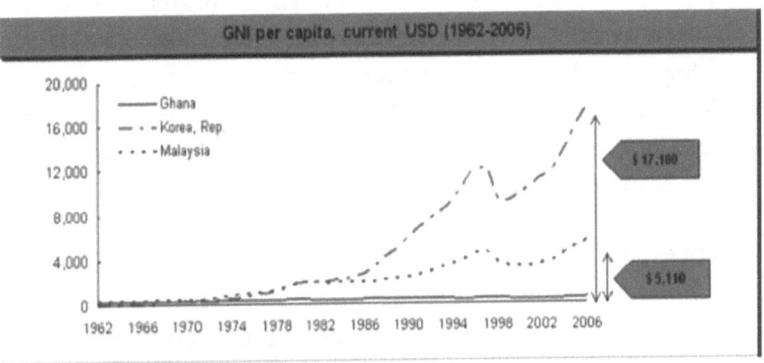

Source: KDS compilation using World Bank data

As graph 1.1 shows the current economic disparities between Ghana, South Korea and Malaysia are wide and apparent. South Korea is a highly industrialized high income economy with a per capita GNI of $17,690. Malaysia is an upper-middle income country with a per capita GNI of $5,620. Ghana is a low income

economy with a GNI per capita income of $510. Yet these countries economic conditions four decades ago were very similar.

As a first step to setting the national tasks for poverty reduction through SME development we need to examine the relative factors for economic development. To put Ghana's relative economic stagnation within an international context, the study uses South Korea and Malaysia because of the two economies similarities to Ghana's in the 1960s.

In 1965, Ghana's GNI per capita (Atlas) was $220 in current US Dollars compared to $130 for South Korea and $330 for Malaysia. The economic size of the three countries (in GDP) at that time was also comparable. Ghana's GDP was 2.05 billion compared to South Korea's 3.01 billion and Malaysia's 3.18 billion. Both Ghana and Malaysia achieved independence from the British in 1957.

Twelve years earlier, in 1945, South Korea had achieved independence from Japan. All three countries therefore suffered varied colonial experiences.

You can see from the graph that Ghana's economy collapsed after 1966 and not before the 1966. The Economy was rather collapsed by the Government that came after 1966

Despite the massive drop in the price of cocoa on the international market that derailed his 7years development programme, all public servants received their salaries and emoluments at the time of the alleged economic crises.

ACHAMPONG COUP—CONDITIONS PRECEDENT

The country suffered from four major decisions taken by the Busia Government when it took power from the NLC Government.

1. **The Alien's Compliance Order**: This order was made with aim of deporting all aliens without Resident Permits. This was made to satisfy general agitation against so called domination of the economy by aliens or non Ghanaians, especially by those of Middle Eastern extraction i.e. Lebanese, Syrians and also Nigerians.

Unfortunately, almost all the labourers on all cocoa farms were "aliens" from Burkina Faso, Niger, and Mali, etc. who had no Resident Permits; and there was a mass exodus of these people who lived on the farms without specific wages apart from yearly bonuses. It is important to note that the cocoa farmer was basically, an absentee farmer.

The exit of these people dealt a major blow to the cocoa farmer and subsequently the cocoa industry. The cocoa farmer lost his cheap labour.

2. **The Second Major Blunder of The Busia Government Was The privatization of Cocoa Purchases:** This resulted in the formation of a host of cocoa buying companies and agencies who collected the cocoa and never paid the farmers, compelling them to abandon their farms and consequently reducing the national revenue.

3. **Open General License (OGL):** To regulate expenditure on imports the CPP Government operated an Import Licensing System. The Busia Government on assumption of power scrapped this system and introduced the Open General License that allowed mass importation of everything. Many companies with accumulated dividends that could not be repatriated due to lack of foreign exchange seized this opportunity to import all sorts of non essential items including drinking water, in order to repatriate their dividends. This action essentially wiped out the National Foreign Reserves compelling the Government to devalue the currency. This was the 1^{st} major devaluation of the currency and did not go well with the population.

THE SALLAH-CASE—NO COURT:

4. The Busia Progress Party Government also sacked 568 public servants for "poor" performance. A senior public servant by

name Sallah took the Government to court for wrongful dismissal and won the case. The Busia Government stated that no court could compel it to work with people it did not want. This reaction created great uncertainty and hostility among public servants resulting in strikes nationwide. The Government reacted by disbanding the TUC (Trade Union Congress).

Simultaneously, the Government started privatizing the state enterprises at a time when the private sector did not have the capacity to take over the enterprises. It was perceived that the divested enterprises were going into the hands of PP (Progress Party) members.

It is important to note that at this time the CPP had been banned. In fact, it was a crime to hold or possess Dr. Nkrumah's effigy in any form, pictures, t-shirt, coin, book, or anything that had his picture.

Under a decree No. 223 no senior member of the CPP had a right to engage in any formal business. The assets of the CPP and many of its high ranking officers were confiscated to the state.

CHAPTER III

GENERAL ACHAMPONG'S RULE

The overall result was to send the economy into a serious recession encouraging the military to take over the country under General Kutu Achampong with his NRC (National Redemption Council Government).

General Achampong embarked upon a serious self reliant policy to resuscitate the economy. He encouraged all the major manufacturing companies to produce their own raw materials. The establishment of Benso Oil Palm plantation—a joint venture between Lever Brothers and Ghana Government is one of such examples. General Achampong also set up Regional Development Corporations for all regions. Under this programme cocoa, coffee and other crops were cultivated as large plantations;

Twifo Oil Palm Plantation was born out of this programme.

He renationalized most of the companies perceived to have been wrongly acquired from the state in order to take the commanding height of the economy.

Mr. Ebo Bannerman, now Dr. Ebo Bannerman of Plan Consult, was the head of the Central Regional Development Corporation and did a great job in establishing the Twifo Oil Palm Plantation now sold to Lever Brothers.

The State Farms Corporation was encouraged to expand its oil palm plantation by embarking on a 20,000 acre oil palm project named JOFA i.e. Jukwa, Okumeni, Fosu and Akwansem. These were 5,000 acre units at each locality.

Unfortunately, these projects collapsed under the PNDC when a scientific officer, one Dr. Adjei Marfo, of the CSIR, virtually high-jacked the farms. One hopes that there will be a time in the history of this country when people will be held accountable for their actions.

Achampong's greatest success was his Operation Feed Yourself (OFY). This encouraged mass participation of the population to go into agricultural production. Even though public and civil servants were not permitted to engage in any business of profit, the programme specifically encouraged Civil and Public Servants to engage in farming activities, resulting in massive production of maize, rice, poultry etc. This gave a huge boost to the economy.

Under Achampong Ghana started the production of its own vehicles, Adom and Boafo

The economy showed signs of real recovery. Ghana Airways made its first and only profit during the time of General Achampong, and this was the time Col. Abekah Jackson, an inventor of international repute, was heading the organization.

Achampong's NRC Government lost hold of the economy when the price of crude oil went from about $4.00 a barrel to over $35.00 / barrel as a result of the Arab-Israeli war.

My candid opinion is that Achampong showed more genuine commitment to this country's development than any leader apart from Dr. Nkrumah.

(Appendix I below is an address made by Col. Abeka Jackson on the Acheampong Regime)

APPENDIX I

"GOVERNANCE SINCE INDEPENDENCE"

ACHIEVEMENTS AND CHALLENGES UNDER

MILITARY RULE

At British Council Hall—Nov. 26, 2007

COL. JACKSON ADDRESSED GHANA ACADEMY

OF ARTS AND SCIENCES

Nations raise armed forces for their defence and protection. During the colonial days, we came under the protective umbrella of the British Armed Forces. Troops from Gambia, Sierra Leone, the Gold Coast and Nigeria were put together as the Royal West Africa Frontier Force (RWAF). We fought alongside the British army under the British Flag in the two World Wars.

When we became independent, our parliament formed the Ghana Army. The Ghana Navy and Ghana Air Force were formed in 1958 and 1959 respectively. Our military therefore comprises the Army, the Navy and the Air Force.

The military was assigned the responsibility of the defence and protection of the territorial integrity of Ghana by land, sea, and air. Our soldiers were also trained to perform internal security duties as well as giving aid to the civil authority in times of crisis. The role of the Armed Forces has been expanded to include assignments requested by the UN, the OAU (now AU) and the ECOWAS.

Our Armed Forces have been trained to the high standard of the British Armed Forces with the only difference being in the level of sophistication and responsibilities. Our military personnel are known for their professionalism, courage and loyalty.

They remain subservient to the government in power. They have a civilian head in the person of the Minister of Defence. Their Supreme Commander is the Head of State. Officers and men who are passing out of initial training swear an oath of allegiance to the state. Therefore when the military staged the coup in 1966 to overthrow the 1st Republic this came as a big surprise. Since then there have been three more successful coups: the Acheampong coup of 1972: the Rawlings coup of 1979 and finally another Rawlings coup of 1981.

In the 1960's there was a perception that Dr. Kwame Nkrumah, the President of the first Republic was a dictator and a communist, whose peccadillo was that he was steering Ghana into Socialism. In the opinion of the opposition and that of the Western Observers, it would not be possible to effect a change of government through the ballot box. Therefore the military overthrew the 1st Republic so that Ghana could be put back on track to multi-party democracy.

By this time, Nkrumah had set Ghana on the path of systematic industrialization. He had a comprehensive network for scientific and technical development. He had laid the foundation for national take-off on all fronts. The major challenge facing the NLC which succeeded the first Republic was how to destroy Nkrumah's shinning image. The military regime tore down everything Nkrumah had toiled to set up. Ghanaians who were training in various Eastern countries were brought home and dumped. Projects supported by the East were abandoned and some equipment was returned to their suppliers in the East.

Affected projects included the International Airport at Tamale, the African High Command, the Naval Base at Sekondi, the National silos and many Derivichi project. Ghana Airways 'Illusion 18' Aircrafts were returned to the Soviet Union. The clock of development was wound so far back that, to date, after forty years, Ghana is still groping and bumbling around in the dark. However,

the NLC set up a Centre for Civic Education, conducted elections and successfully put Ghana back on the tract to democracy.

Dr. Busia, the Prime Minister in the 2nd Republic stepped on the toes of many Ghanaians including the courts, the civil service and the military. In his effort to improve the economy, Busia devalued the cedi by 41% and cancelled allowances paid to civil, as well as public servants. In the end, Busia went round with a hat in hand seeking donor support.

It was at this time, one Lt. Col. Kutu Acheampong felt Ghana deserved better than what Dr. Busia was offering. Acheampong believed that since Ghana was heavily endowed with natural resources, Ghana could become self reliant if she had a good leader. Acheampong believed he could offer the required leadership.

In January 1972, Lt. Col Acheampong led a bloodless coup to topple the 2nd Republic. He then set up the National Redemption Council (NRC) which became the SMC I and SMC II government. Acheampong's vision was "Self Reliance." Acheampong unilaterally cancelled some of Ghana's debts under a policy he called "Yerintua—we won't pay our debt." (The perception was that most of those loans were fraudulent-'Authors observation'). He launched a series of actions to meet the needs of the masses. He considered these to be Food, Shelter, Clothing, Transport and Communication, Economic Empowerment, Industries, Energy, Education and Patriotism.

FOOD: Acheampong's green revolution—Operation Feed Yourself (OFY)—was most successful. The elite, who hitherto did not like to be associated with farming, became proud absentee farmers. Farm inputs, including machinery, were rated duty-free. The government completed and also built new large irrigation projects. These were the Vea, Tono, Afife, Tuba, Asutware, Komenda and Dawhenya farms.

The government also set up a transport task force comprising farm tractors, four-wheel drive vehicles and heavy cargo vehicles for hauling food stuff from the farm-gate to the regional centers. The Agricultural Development Bank was encouraged to support the green revolution. By the end of the first year, 1972, Ghana was

self sufficient in food. In 1973 and 1974, Ghana was a net exporter of food.

SHELTER: The NRC boosted housing projects. The State Housing Corporation (SHC), the Tema Development Corporation and some Regional Development Corporations built 2000 housing units a year. Individuals were urged to build houses and organizations were encouraged to set up housing loan schemes for their staff. Thus, the Armed Forces had their Housing Loan Scheme and the Civil Service also had theirs. The Bank for Housing and Construction was set up; to cater for the construction sector.

CLOTHING: Under the operation Feed Your Industries programme, the Cotton Development Board fed our Textile Industries with cotton. Some Ghanaian industries produced cotton, underwear and towels.

TRANSPORT AND COMMUNICATION: There were more than ten vehicle assembly plants led by Neoplan and Willow-brook which produced buses for intercity and intra-city transportation. Other companies produced mini-buses and assembled cars. Some indigenous creations were the Boafo and Adom vehicles. Few Boafo vehicles could still be seen plying the road in Tema.

Acheampong up-graded GTV to colour; Point to point radio communication was also encouraged.

ECONOMIC EMPOWMERENT: The State took 51% shares in a number of multinational companies for Ghanaians. Today Ghanaians have shares in Unilever and other companies. Foreigners were banned from petty trading.

Thus, Acheampong meant to put the commanding heights of the economy in the hands of Ghanaians.

INDUSTRIES: Owing to Acheampong's "Yerintua" policy, investments were not flowing from outside, yet, Acheampong managed to keep our industries working. Asutware and Komenda sugar factories supplied our needs. Bonsa Tyre Factory supplied tyres for road transport, farming as well as construction.

ENERGY: Acheampong built the Kpong Hydro-Electric Dam to boost power generation. Fuel prices were kept low to the

detriment of the economy. He showed interest in the rehabilitation of the Atomic Energy Commission.

EDUCATION: The NRC previewed the JSS concept and decided to start with a pilot project of ten schools which they called "the continuation school." Acheampong wished a new educational system could produce Human Capital for production and industrialization.

PATROTISM: Acheampong introduced the National Pledge and a Slogan "One Nation, One People, One Destiny." General Acheampong's biggest challenge was the oil crisis of 1973. Although our oil bill rose from $24 million in 1972 to $125 million in 1978, Acheampong never increased fuel prices; Ghana's net foreign exchange earning reduced while prices rose on the global market. As a nation we could only afford a fraction of our normal imports. The shortage of goods created a "sellers" market which Ghanaians called "KALABULE." The economic situation and wild rumors battered and weakened Acheampong's government. Acheampong proposed the formation of Union Government in the hope that it would reduce rancor in multiparty politics. This was vehemently rejected because, by this time, the people were fed up with military experimentations.

In June 1979, the AFRC headed by flight Lt. J.J. Rawlings, violently overthrew the Acheampong government. The aim of the new rulers was to bring down Acheampong's military government as well as punish members of the Junta. This was accomplished with executing the generals by firing squad. In their effort to kill kalabule, the AFRC forced traders to sell goods below cost. They terrorized the nation. They reigned for only 112 days and handed over to the 3rd Republic who had then won the election and was led by Dr. Hilla Limann.

The leader of the AFRC, Lt. J.J. Rawlings took over government again and this time formed a revolutionary government called Provisional National Defence Council (PNDC). The World Bank and the IMF supported the PNDC to put Ghana's economy on its feet. The Government passed the Intestate Succession Law (PNDCL 1 1 1) which has brought relief to many bereaved families.

In conclusion: The NLC put Ghana back on track to democracy. Acheampong's NRC, SMC I and SMC II showed how Ghana could become self-reliant. The ARFC showed that people could be held to account for their stewardship. In the final analysis, the challenges which faced the military governments as well as subsequent governments could be summarized as follows:

- The oil or energy crisis. The need to generate more power.
- The development of our human resources into human capital for wealth creation. Our people must be given knowledge and skill.
- An all inclusive government that will remove rancor from multiparty politics. Executive power must be shared instead of "the winner takes all practice."

When we solve these challenges, we shall enjoy stability, prosperity and peace of mind.

I wish to advise our politicians to desist from fanning conflicts or ethnic sentiments which have the potential of igniting the society into social conflagration, thus giving the military the easy excuse to come back in the guise of saving the society.

Finally, my message to the military is that we know they are very good at peace-keeping. They should keep the peace in Ghana by no more disturbing the peace we are enjoying.

THANK YOU

CHAPTER IV

PNDC/NDC

I believe that Ft. Lt. J.J Rawlings exercised more power than any leader that I have known in my life. When Ghanaians were forced to sleep (curfews) for three years, nobody resisted. Ghanaians were forced to give up their monies, houses, companies, factories, etc. and no one resisted because we believed it was a sacrifice that was necessary. Ghanaians gave up their lives. But what did we receive in return? (Consider the man-hours-lost for nothing)!

Meanwhile, General Park of South Korea took power and within 18 years, exercising far less power, shot South Korea to the sky. The Malaysian leader, Nehru of India, the Singaporean leader, all exercised less power and had fewer resources but managed to lift up their countries.

I must confess that I had close interaction with J.J. Rawlings before his second coming and I believed in his sincerity to fight corruption and to advance the economy of this country. Unfortunately, his utterances that appeared to target the economically successful entrepreneurs tended to alienate such people from associating themselves with the revolution. In the eyes of J.J Rawlings all economically successful persons were crooks and had to be persecuted. Certainly this could not be true. For at the time he took over power, there were many Ghanaians in their 50s, 60s, and even 70s who had worked very hard and built financial empires from their own steam. Most of these were very honest and righteous citizens who were also not happy with the way some others had made money by exploiting the system.

These people were willing to join the revolution but found themselves unacceptable within the ranks of J.J. and his immediate colleagues. These people could have shared their entrepreneurship experience with J.J to put the economy on the path similar to what Gen. Park of South Korea had chosen. Many knowledgeable public servants could not fit into his style of management and therefore were reluctant to join his Government. The entertainment business and the Art Center all had collapsed as a result of his curfew and by so doing had allowed other countries especially Nigeria to overtake us in the field of cinematography, arts and general entertainment.

The PNDC/NDC Governments had huge financial resources from donors. When they took on power the cedi was about 2 cedis to one U.S. dollar. When they exited, the rate was 7,000 cedis to $1.00 a depreciation of about 3,500%. One could count the number of street boys and girls at the onset. This group had turned into an army. Over 300 state enterprises were divested. The structure of the economy was the same as at 1844; i.e. reliance on the agricultural and industrial raw materials.

Their action, for instance precipitated collapse of GIHOC (Ghana Industrial Holding Corporation), created a huge technological gap, in that the experienced artisans and craftsmen, from the affected enterprises could not transfer their technical knowledge and experience to a new generation because both state and private enterprises collapsed simultaneously. This was a major blow to this economy.

Unfortunately, both NPP and NDC also failed to take advantage of the <u>CARIOUS MOMENTS</u> the appointment of Dr. Kofi Annan, as General Secretary of the UN to use UNIDO Resources (United Nation Industrial Development Organization) to build up a base of technocrats and artisans.

Dr. Kofi Annan's regime was more or less equally shared by both parties, even though one must concede that the NPP had a bigger share of the period.

Ghanaians should at this point, remember that India used UNIDO resources to establish among others:

(1) Advanced Machine Tool Center—giving them capacity to replicate any machine.
(2) Automobile Research and Development Center-giving them power to build any vehicle.
(3) Bicycles and Sewing Machine Center-giving them capacity to develop and manufacture numerous allied machines (printing, textile etc.)
(4) Glass Research-helping them to go into new materials such as Fiber Glass, Insulating Materials etc.

UNIDO provided 70% financial support for the establishment of all these centers. **(Ye Nua Ne Memuna, Nanso Koose Hia yen.)** Our sister is Memuna yet we could not access Koose.

When Mr. Mahama the then aspiring vice-presidential candidate of the NDC said "any attempt to compare records of NPP and NDC would be a RECIPE for MEDIOCRITY," we did not understand. If you sat an exam and you had 1/10 and your competitor had 2/10 both of you have failed. All what Mahamah was stating was that, his government, the NDC, had not done much, so comparing their records as basis for evaluating their performance was a non starter! I rest my case for the NDC and NPP.

CHAPTER V

(Woode, 2004)
(Below is an extract of a memorandum sent to Government in 2004 on "The Presidential Cassava initiative.")

"THE PRESIDENTIAL INITIATIVE ON CASSAVA AND STARCH PRODUCTION IN GHANA (NPP INITIATIVE)":

PREAMBLE

On assuming political power, the NPP Government embarked on a number of Special Initiatives designed to reduce poverty especially in the rural areas. The strategy was to use agro-processing as the main driving force for poverty alleviation.

The Cassava-Starch Project at Ayensu in the Central Region aimed at cultivating and processing thousands of tons of cassava under private sector development, was the first of such Special Initiatives.

Under the scheme about 20,000 farmers were being mobilized as part owners of the project to cultivate and supply cassava to the Starch Factory at an agreed price. There have been many discussions on the viability and sustainability of the venture. One of the pertinent questions being asked is whether cassava is a wealth creating crop. Many observers are worried about the low yields (National average 12tons/ha) the high parallel demand and price as well as its high perishability. The low world market price is also a worrying factor.

C.T.E.D.—Centre for (knowledge based) Technology Driven Economic Development has followed with great interest the recent debate on the Cassava/Starch initiative. To help the debate we present the following facts:

1. In the year 2000 world cassava production was about 175.6 million tons, out of which Ghana produced about 8.1 million tons, Nigeria 33.9 million tons, Thailand 18.8 million tons with Brazil producing about 23.8 million tons.
2. In 1995 the price of Tapioca flour/starch stood at $358.00 per ton (FOB Bangkok). The price of raw cassava (roots) was $65.00 per ton.
3. By the year 2000 the price had reduced to $158.00 a ton i.e. a loss of $200.00 in five years. The equivalent world price for cassava (roots) was $21.00 per ton or approximately $1.00 per "anto" bag of 50kgs. At the then exchange rate of ¢7,000.00 to $1.00, it meant the equivalent of a 50 kg bag was ¢7,000.00. Meanwhile, the open or parallel market price was ¢40,000.00 or really $6.00 i.e. over five times more than the equivalent world price.
4. Year 2001—Jan-March Starch $158.00: Cassava $21.00: April-June, Starch $177.00, Cassava $32.00: July-August Starch $185.00; Cassava $31.00 Source: FAO/GIEWS—Food Outlook, No. 4, October 2001 page 11.
5. For the past few months starch price has fluctuated between $200.00 and $170.00 a ton and cassava price had not exceeded $35.00 per ton.
6. Presently, (2004) farmers are receiving ¢150,000.00 per ton or ¢7,500.00 for a 50kg bag. Unfortunately because of the low international price for starch coupled with high processing costs including transport subsidies to farmers Ayensu could not afford to pay more, since it might itself collapse.
7. Given a yield of 20 tons/ha maximum revenue from a hectare is (2004) ¢3 million. Since the average farmer

cannot cultivate more than 2 ha or 5 acres equivalent to about 4 football fields, the average gross income for a family of 4 would be (2004) ¢6 million per year or ¢1.5 million per person which is less than $200.00 per annum or approximately 2/3 of National per Capita of $370.00.

(Please note: all cedi mentioned in the above content are old cedis.)

SUGGESTION:

In addition to the existing plans including the introduction of hand operated mechanical harvesters and improved planting materials, we need to do more to support the farmers to survive. However, they can only be supported meaningfully if the price of starch improves or if the starch factory can make more money through secondary and tertiary processing of starch into higher value products like monosodium glutamate (MSG), glucose, alcohol, etc.

It will be in the national interest to encourage private investment to team up with the Ayensu Starch Factory to go into higher value products. Otherwise we must channel some of the monies earmarked for new starch factories to support Ayensu to go immediately into secondary and tertiary products in order to sustain itself and the farmers.

The danger is that if the farmers continue to be dissatisfied with the present prices, there will be the high probability of cassava being diverted to the parallel market—for gari, agbelemah, etc. Such an action will definitely create problems for Ayensu since it cannot buy cassava at the parallel market price (4-5 times the world market price) process into starch and sell at world market prices. It will just not survive!

Let us take a scenario where Ayensu is compelled to buy cassava say at ¢20,000 per a 50kg bag. The ton would be 20 x ¢20,000 or ¢400,000.00.

Since the extraction from cassava to starch is 5:1, the equivalent amount for a ton of starch will be ¢2 million less processing costs.

At $200.00 per ton of starch the world price equivalent will be ¢1.8 million i.e., ¢200,000 more than the direct conversion, i.e. less processing costs.

Cassava has over 70% moisture. Adding 20% dry mass of starch gives you 10% total residue—spent meal, fibre, skin, cork, etc.

	Analysis of 9-12 months cassava	
	% Net Weight	
1	Moisture	65—70
2	Starch	21—25
3	Sugar	5.1
4	Protein	1.1—3
5	Lipid	0.1
6	Crude Fibre	1.1—2
7	Ash	0.8

Revenue from this 'waste/byproduct' can never cover our production cost especially in a situation of high electricity tariffs, water and other utility costs.

It is absolutely important that we derive a minimum of $350.00 from a ton of starch since this will make it possible to pay about $60.00 for a ton of cassava. In which case, farmers can obtain ¢500,000.00 a ton or ¢25,000.00 for a 50 kg Bag.

Since we do not have any control over the world price our best chance is to go into secondary and tertiary products that are not affected by world prices.

Meanwhile to cut factory processing costs and reduce transport subsidies to farmers it might be necessary to encourage farmers to supply "crude" starch to Ayensu for refining. A small plant consisting of a grater mounted on a strainer and a water tank is all that is necessary.

Water from the tank is directed on to the grated cassava as well as into the strainer, which consists of a horizontally mounted shaft carrying multiple brushes rotating in a cylindrical fine mesh. The strained water which has absorbed the starch is recycled many times to obtain a starch concentrate. Starch is then trapped in cotton sacks or where possible in filter chambers. This system produces fairly high quality starch which may be refined in a "Mother" factory. Components of these simple plants are being manufactured locally for application in oil and juice extraction. It should therefore pose no problems by my company FATECO LTD.

Allowing farmers to do farm gate processing helps them increase their revenue and reduce transportation expenses. Losses through fermentation are also cut down since cassava may be processed immediately it is harvested.

The establishment of a Machine Tool Technology Centre linking up with other engineering machine building companies, will facilitate the manufacture of simple engines (probably fueled by biodiesel) and the equipment and machinery required for this kind of enterprise as well as other agro-processing enterprises.

C.T.E.D is therefore urging Government to set up such a Centre by obtaining funding from UNIDO as was done by India, Tanzania, Korea and others. It is absolutely important to pursue this while Kofi Annan is still at post as he serves his last term of office. We need to remind ourselves again that the Poverty Gap is a Technology Gap.

If Ghana were to achieve machine building capacity, products like tapioca, glue, etc. may also be manufactured at farm gate, thus giving credence to the Rural Industrialization Programme.

We need to remind ourselves that cassava is a heavy consumer of nutrients, it is important to alternate planting with a nitrogen

fixation crop like soya been. This will also help reduce plant diseases, pests and rodents.

It is sad to observe that even though Ghana was a leader in cocoa bean Production, we never managed to excel in cocoa processing technologies. Like Malaysia which achieved tremendous <u>gains in palm oil</u> technologies using indigenous scientists, we have allowed other countries to lead us with respect to secondary and tertiary cocoa products.

To avoid a repetition we should take steps to build our capacity in processing technology by immediately attaching students from KNUST, the Polytechnics and staff from Industrial Research Institute to the new starch factory with the main aim of familiarizing themselves with the existing technologies, using the internet for additional information and preparing ourselves to build even more advanced plants within a time frame. If not why not!

CHALLENGES

CONVERSION:

- Value—Added Products
- Farm gate processing
- Machine building capacity

CONNECTIVITY:

- Private sector led
- Government facilitated
- Institutionally supported

COMPETITIVENESS:

- Yield per hectare
- Building systems
- Marketing strategies
- Local

- Regional
- International

INITIATIVES:

- Cassava Mosaic Disease (C.M.D.) Pre-emptive Programme
- Cassava Enterprise Development Programme domiciled in IITA—a shell/USAID initiative (IITA—International Institute for Tropical Africa in Ibadan, Nigeria)
- Enhance the existing Presidential Initiative on cassava involving cassava production, processing and marketing in domestic and export market to include secondary and tertiary processing and manufacturing technologies.
- IFAD programme on cassava production complementing dissemination of improved cassava varieties.
- USAID/Project on cassava utilization for livestock feeding.

OTHER INDUSTRIAL USES of Cassava:

1. In composite flour for bread and confectioneries
2. Use of chips for production of ethanol.
3. Use in sweetness and flavorings.
4. Use in cereal based foods e.g. indomine nodules

Dear Ghanaians, poverty has made us lose our dignity. Any person who loses his dignity can be abused. This is the only reason why we are even abused by foreigners in our own country. Let us shake this self-imposed poverty by creating wealth through a national development strategy which is knowledge based and Technology Driven.

"This is what **C.T.E.D** stands for."

CHAPTER VI

THE ECONOMIC REPERCUSSION:

There is a Twi proverb that translates as "The bile is attached to the liver". In other words there is always a bitter part of whatever is tasty.

Dr. Kwame Nkrumah was overthrown principally because of his alleged human rights abuse. Ghana therefore threw out the baby with the Bath Water, resulting in the suspension or the cancellation of many great projects which could have placed us on the same level as China now.

China is great because it used the "structured approach" for development which meant that state institutions were used as Research, Development, Production and Training Center's resulting in the mass empowerment of the people in the three major parameters of wealth creation—i.e. Knowledge, Finance and Technology.

The subsequent denationalization of the system created a huge mass of capitalist fully empowered and enriched by their God given talents to take on the world by STORM, and setting the stage for private sector as the engine of growth.

The intention of the writer is to produce a document which may just be described as Nkrumah's achievement at a glance. Since detailed description of Dr. Nkrumah's projects will require virtually hundreds of pages of writing, I will only skirt around the projects.

At this juncture, I wish to list a few of the major projects which were either suspended or cancelled and explain their importance to the nation.

WATER:

For the past 20 years (1990-2011), Accra has gone through serious water shortages. The main problem is due to population explosion. Unfortunately we as a country embarked on cosmetic solution-erection of reservoirs. In this regard, 13 large fibre glass reservoirs costing over 3 million pounds were imported and erected at various spots in Accra. The writer can say without fear of contradiction that the overhead tank erected at the Accra Teacher Training Centre on the IPS Road even though it claimed one life since its erection in the 1990 never saw one liter of water.

Nkrumah's policy on water ensured reliable water supply to all homes connected to the water grid.

Under Nkrumah's programme the Onya basin, Agbogba—Kwabenya valley, was to be damned to create a lake. The main purpose of the lake was to stop flooding of Accra. Calculations indicated that water from the Aburi Hills down to Adenta area was the main cause of flooding in Accra. The dam was to be used to control flow of water into the Odaw River. A water purification plant was to be installed to complement water need in Accra. Incidentally there was a small water purification plant behind the Kwabenya ACP Hills erected by the British Colonial Government for the then Pokuase Agriculture Station which at the time of writing had also been allowed to collapse when the Ministry of Agriculture took over the station after the State Farms went defunct.

The major water supply programme was to come from the implementation of phase II of the Kpong water works. Since the overthrow of the CPP water expansion programs have taken place at Weija instead of Kpong.

The writer is unhappy about that because it is common knowledge that Accra is expanding northwards, furthermore the growth of many villages in the Densu basin and the expansion of Nsawam, has put great stress on the Densu with respect to its pollution. As at 2009 Ghana Water Company was spending 6,464,000 ghc per month on 1,013645 kg of alum for water purification. In addition the company was buying 73704kg of lime and 36,050kg of chlorine

also per month. The bulk of this expenditure was for Weija Water Works. These figures are likely to escalate as settlement activities increase in the Densu basin. It is common knowledge that the Densu is under threat. The river has shrunk greatly compared to its size 50 years ago. It is absolutely important to put resources on the Volta which discharges 1000 cubic meter per sec. when three turbines are working or 2000 cubic meters equivalent to 2000 tons or 2 million liters per sec. when all six turbines are working. In other words calculating on the population of 30million, every Ghanaian could access 240 liter of water, three times our normal daily requirement in one minute. Is it not shameful that we can't get water for ourselves in Accra only a few miles from the Volta? After 53 years of independence, could this situation had occurred in Korea or India?

From the contour map accessed through Google GPS (Global Positioning System), it is obvious that erecting our water reservoir on the Asutware Hills will ensure that water can reach most part of Accra under gravity. Furthermore, erecting a 50 meter wind turbine on the hills will provide at least 300,000 Kwa of electricity for pumping the water up hill and for the enlarged treatment plant. From my calculation our power requirement will be for less than 300,000 Kwa.

With large quantities of Bauxite, we should produce the alum we need, since alum is produced by "cooking" finely ground bauxite with particle size (200 mesh) with sulfuric acid, black ash, flake glue and subsequent precipitation. This is not high tech. Let us move Ghanaians. Let's take steps to phase off the Kuffour/Attah Mills Gallons!

In the recent spilling of the Volta River at Akosombo, Ghana at that time was at peak discharge of 40,000 tons / second of water equivalent to running 20 Akosombo power stations. We need to take steps to create inland water reservoirs to prevent a repetition of this as it's done in the U.S.

POWER PRODUCTION / ENERGY

CRUDE OIL EXPLORATION:

Dr Nkrumah invited the Romanians to investigate the presence of crude oil in the Volta Basin.

Test Drills for oil were conducted at Atiavi. A small settlement was set up for staff of the exploration team. Soviet specialists were also invited in petroleum exploration in the area. Unfortunately, the Coup truncated this effort.

Dr. Kwame Nkrumah was aware even in the sixties that Energy was a major prerequisite in a value addition chain. He therefore took steps to enhance our energy supply base by embarking on the construction of the Bui Dam.

Taking advantage of the geopolitical situation in those days he enticed the then Soviet Government to build the Bui Hydropower as the Americans were building the Akosombo Hydro power station.

At the time of the 1966 Coup all the design drawings for the Bui Dam had been completed and large quantities of constructional equipment and building materials including steel beams, angles, plates, large pumps, diesel electric generators and miscellaneous tubing were all at site. All these materials gradually disappeared from the site without anybody accounting for them.

Dr. S.B. Arthur, a Soviet trained Ghanaian Hydropower engineer, had surveyed the hydropower potential of all the rivers in the country and had quantified their energy potential. For his thesis, he estimated that the Volta Basin had potential to produce 4300 mega watts from 7 possible sites using the cascade method.

Unfortunately it is not possible now to achieve this because we failed to protect the Basin. As a result of massive deforestation, the land can no longer retain its top soil which is continuously being washed into the river and thus causing siltation resulting in the spread of the lake and consequent higher evaporation.

At the time of writing Accra alone was receiving 60 truckloads of charcoal equivalent to at least 240 truckloads of fire wood every 24 hrs. The main source is in the North and Afram plains—the

catchment rain source of the Volta River. My estimate is based on 25% extraction rate. I can say without fear of contradiction that because of the inefficient method of charcoal production, there are cases where the extraction rate is only about 15%. Dr. Kwame Nkrumah did not live to see his dream of power from the Bui come true. The project is now being handled by the Chinese in the year 2008/2009.

The question that troubles me as an Engineer is that we had the Akosombo Hydropower which is four times bigger in capacity than the 400 mega watts Bui plant.

Furthermore, the Bui Lake is much smaller. The Akosombo Hydropower was built nearly 50years earlier (two generations). Why is it that we as Ghanaians are compelled to bring in a third party to build the Bui Dam? I ask myself if the Indians or the Koreans had been in this position would they have called on a third party to do this? Our KNUST was in existence over 50 yrs ago (2011). The South Koreans had the equivalent of our Engineering Universities i.e. KIST—"The Korean Institute of Science and Technology," 15 yrs after the establishment of KNUST. The Koreans do not invite third parties to build their hydropower plants, so why? Why? I don't believe that if Kwame Nkrumah had lived till now, this situation could have happened.

Yes our political leaders must be compelled to explain this.

ACTION BY POLITICAL LEADERSHIP:

Our political leaders must not allow this situation to repeat. We need to take steps to empower our people now to have full capacity to build Hydropower Plants. We must have a programme with quantifiable targets to achieve this. Whatever needs to be done must be done now for we still have a number of small rivers and stream with hydropower potential. The Pra River has potential to produce 120 mega watts of power. This has been confirmed by a young engineer by the name Allan, the son of the first person to build a local Sugar Production Plant at Makensem in the Central Region

In this regard, I wish to remind political leadership that about 6 yrs ago (2005), Ghana received two by 30 kw hydropower plants from UNIDO for study and replication. The deal was facilitated by a close friend of mine Prof. Damodaran who happened to be the deputy head of small and mini hydro plant—a UNIDO project in China. As at the time of writing 2011, the plants are still in boxes at V.R.A. depot in Tema. I have publicly raised this issue many times but to no avail.

Would this have happened if Kwame Nkrumah were in power? Certainly not! This is my reason for choosing the topic **"The Economic Repercussions of the Overthrow of Dr. Kwame Nkrumah."**

It is common knowledge that power can be derived from water dropping at the height of 9 feet. In other words, if you could erect a weir 9 foot high over a stream you could get power from a hydro plant. Of course the quality and speed of flow would determine the quality of power to be derived.

CHAPTER VII

SUSTAINABLE BIOFUELS IN GHANA

PREAMBLE:

There is evidence to assume that crude oil, natural gasses and other non renewable energy sources are limited.

There is no evidence that God is creating more of these non renewable resources.

There is evidence that due to population increases the demand on the existing resources is increasing.

As at the 2007 per capita consumption for the average American was 24 barrels of crude oil per year. That of the European was 12 barrels, the Chinese 2 barrels and the Indian-one barrel.

In that same year, the world had about 800 million vehicles. In fact Ghana imported 40,000 vehicles in 2007.

It is common knowledge that the Chinese are now abandoning their bicycles and resorting to driving cars. In 2008, V.W. sold one million cars to China.

Presently the Chinese want to live like the Americans, China's population is about 1.6 billion (2008). If they increase their consumption from 2 to 4, they alone will require 6.4 billion barrels. The world cannot tell China not to abandon its bicycles. Meanwhile, India is also following the footsteps of the Chinese. India is nearly 1 billion in number.

Presently there are three main causes of oil insufficiency:

a. Geological—Not enough available.
b. Economic—Not enough to meet the growing population of Asia, Indian and Brazil.
c. Geo Political—Concentration in précised areas.—Persian Gulf, Middle East / Russia.

We are all aware that the world economic system is based on growth. This growth is premised on low oil prices for energy production.

SOLAR ENERGY:

The Sun can be described as the principal source of energy for the universe. It is estimated that 5.7 hours of sunlight is enough to meet a year's energy needs of the world. It is further estimated that solar energy dissipated on 1sq km of the Sahara Desert is equivalent to 1.5 million barrels of crude oil.

Ghana's unique position on the globe only 4 degrees above the Equator and the meridian passing through Tema gives us exceptional advantage to tap energy from the sun.

We can harness the sun's energy in three direct ways:

1. Water heating through coils over black metal sheet utilizing two tanks
 a. A supply tank
 b. Insulated reservoir tank. Temperatures up to 70 degree C can be achieved if the design is right. Hot water in this form can be used for miscellaneous application.
2. Use of photo voltaic (PV) appliances for generation of electricity for various applications.
3. Enhancing the sun's energy through the use of mirrors for heating water, generating steam and producing power from steam turbines.

WIND POWER:

The author believes that Ghana needs to adopt the comprehensive approach to solving the energy problem. Contrary to general perception that Ghana has no wind potential, it is realized that only Ghana and Senegal on the West Coast have good capacity to produce salt. This is because both countries have a relatively higher wind speed that facilitates evaporation of sea water for salt production.

Findings from the U.S. Department of Energy, the National Renewable Energy Laboratory N.R.E.L, indicate that even at the height of 12 meters, wind speeds reach between 4m/s (meters per second) and 6m/s at Aploku and Mankoadze. Aploku is not far from Pambros Salt Ponds (Menskurom).

The 12m by 18 blades with 5m diameter wind mill being manufactured by the Agricultural Engineering Services of the Minister of Agriculture and FATECO LTD., can produces torque at 1.8m/s wind speed means that such machines can be deployed nationwide for irrigation to reduce energy requirement.

Wind turbines if appropriately deployed in already available wind corridors enhanced under our tree planting programmes can be used to enhance our power needs.

We believe in the deliberate creation of wind corridors for power generation. Anybody can test widespread availability of wind by holding a large cardboard in an open field. With the aid of GPS and the wind map, potential wind corridors can be identified and harnessed for power generation. Wind speed tests conducted at Papaye Fast Food on the Spintex Road gave wind speeds between 7-9 meters per second. At Kawokudi Junction and Mamprobi Beach all in Accra, wind speeds of over 7 meters per second were very consistent. It is now known that wind power is viable whenever oil prices exceed $60.00 per barrel. With the oil price (2008-2010) now exceeding $70, there is no doubt that Ghana should closely pay attention to the potential of wind power.

BIOFUELS:

We refer to any energy source that emanates from biological resource, i.e. plants and animals as biofuel. Since man has capacity to regenerate plants and multiply animals, these energy sources can be described as renewable. We must however understand that the sun is the original supply of this energy. Plants and animals are energy convertors and storers of energy.

As a tropical country, Ghana has immense potential and overwhelming advantage to harness biofuels for energy and power generation. Vegetable Oil, ethanol, biomass and biogas belong to the biofuel group.

Vegetable oil is described as liquid solar energy. It is a hydrocarbon with very similar characteristics as crude oil. The only major difference in the hydrocarbon chain is the presence of an oxygen molecule. Vegetable oils have approximately 9500 k-cal of energy. While gas oil (crude oil) has about 10,200 k-cal. Some major differences in properties include flash point temperatures, densities, pour point temperatures, iodine content etc.

For power generation our main concerns are with its Energy and Flash Point Temperatures. For Gas oil, Flash Point Temperature is between 60-80°c. For vegetable oil the range is between 180-200°c. We are all aware of the formula

$$\frac{P_1 V_1}{T_1} = \frac{P_2 V_2}{T_2}$$

By modifying the compression ratios, i.e. distance travelled by piston in an engine with respect to total displacement in cylinder, it is possible to arrive at a T_2 equivalent to the flash point temperature of the oil to induce firing. Simultaneously additional heating plugs can be inserted to raise the temperature to reach the desired T_2 for firing to occur.

On the basis of this knowledge the German Government is encouraging the use of vegetable oil, specifically palm oil, for power production. A company by name Q.E.W. GmbH has

been established to address the specific needs of Combined Heat Power (CHP) plant operators in Germany. These CHPs have been established in the frame work of the EEG (Emercierbare Energie Gesetz, renewable energy law), which stimulates the use of renewable energy by setting advantageous feed-in electricity tariffs for a period of 20 years, presuming that power is generated in combination with heat for homes. There are about 4000 biogas CHPs, but also about 1,500 vegetable oil CHPs. The vegetable oil CHPs have a combined power of 400 mw and need about 600,000 tons of vegetable oil annually.

Initially (2004) the CHPs used rape seed oil (local product), then after prices started to rise (due to demand for Biodiesel), most of the companies moved in 2005/2006 to cheaper palm oil of Refined Bleached Deodorized (RBD) quality.

Prices delivered to the home were then between 450 and 500 Euro/ton, at the moment (June/July 2008) they are between 800 and 900 euro/ton; Rapeseed between 900 and 1000 Euro. In fact due to the fixed (and therefore ceiled) electricity tariffs, most CHPs do lose money when prices exceed 650 Euro/ton; some even lose money at lower level.

After studying the Palm Oil Industry, the Germans concluded that actual production costs for Palm Oil are in the 150 to 250 Euro/ton range.

It is further realized that West African extraction rates and yields are very low. At the same time production is done without fertilizers and pesticides, so that the palm oil is not grown sustainably!

I assert that no oil bearing seed in the temperate climate has more than 1000kg of oil per hectare. Yet in the tropics such as ours, we have oil bearing trees yielding over 3000kg of oil per hectare.

It is clear that the use of vegetable oil for power production is sustainable in Ghana if we use good methods.

In fact, our calculations indicate that if we can mobilize our people to plant about 7 million hectares of Almond trees—an oil bearing plant, Ghana can produce 20 million tons of vegetable within 6years. On the basis of the German experience 12 million

tons should produce 8000 mw of power; 90 million kw/hrs from the biomass through a gasification process.

Such a programme will create jobs for at least 14 million young people i.e. 2 persons per hector and thousands of others in the value addition i.e. high protein cake, edible plastics etc. 7 million hectors of forest in the Volta Basin would enhance rainfall, rejuvenate the Volta River to restore its potential to produce 4,300 mw of power. The country will also benefit from carbon trading.

Carbon dioxide absorption is estimated at about 100 tons/hectors.

Ghana has untapped resources in vegetable oil. Presently we have about 30,000 acres of Para Rubber Plantation yielding about 30,000 tons of Para Rubber Seed with 42% oil giving us about 12,000 tons of vegetable oil. The Aboso Glass Factory was grounded due to inadequate power. The total demand there does not exceed 1 mw.

From extrapolations above 12,000 tons of Para Rubber Oil should give us about 8 mw. In fact, under President Nkrumah's programme, the target was 75000 acres of plantation within 15 years i.e. ending before 1980 which would have given us 20 mw of electric power.

BIODIESEL PRODUCTION:

For the production of biodiesel for general transportation needs, we only require caustic soda, or potash, and ethanol or methanol.

The process for converting vegetable oil to Biodiesel is quite simple. In other words with 20 million tons of oil and our diesel requirement not exceeding one million tons, we can have a sustainable programme to use vegetable oil to meet our transportation needs. Jatropha is the best feed stock.

At this juncture, let me remind readers that for power generation we need not convert the vegetable oil into biodiesel. In any case, we can easily produce methanol from the natural gas coming as by-product from the crude oil presently discovered.

ETHANOL:

Ghana has enormous resources for the production of Ethanol. All what we need to do is to create conditions for harvesting the raw material—cocoa sweating during the drying fermentation process.

With cocoa production hitting one million tons of dry beans, equivalent by-product from the sweating should be very high. Cocoa Marketing Board should assist the Cocoa Research Institute to design drying platforms that allow harvesting of this commodity. Research Institution including the KNUST should determine the percentage of ethanol from a ton of dry beans. Institute of Industrial Research should link up to this programme by providing table top distillation plants and training programs for its successful implementation. The programme should be extended to link up with State Distillery formerly of G.I.H.O.C. to buy the alcohol from farmers or intermediate distillers for the production of Ethanol. The Bodwoase Starch Plant can surely become more viable if it went into a value addition chain including ethanol production.

Roots and Tubers of the Ministry of Agriculture should be linked to this programme and support cassava farmers with small scale portable starch plants which can be made here for ethanol production.

Sweet Sorghum as a feed stock for ethanol should be encouraged since the stem of the Sorghum is a feed stock, this material does not threaten the food industry, so is the cocoa industry with respect to ethanol.

Ethanol has been used as automobile fuel for many years in various Regions of the world. Brazil is probably the leading user nation. In the 1990s about 5 million vehicles operated on fuels i.e. 93% ethanol. Presently new engines are available that run on flexible fuels, i.e. any mixture of ethanol and petrol.

The country has a lot of miscellaneous plants with both biodiesel and ethanol potential. A value addition chain for our Agricultural raw material base should allow us to identify them.

ENERGY FROM OTHER WASTES:

Biogas can be produced from biodegradable landfills. For economic production of gas from landfills, a minimum of one million tons of land fill must be buried 40 feet deep. This information must guide us in designing our landfills to make sure that we have the possibility of extracting gas from all our landfills nationwide. Landfills designed as a hill can also be used for power generation if we mount a wind turbine on top of this artificial hill.

Biomass with densities above 200kg/cubic meter can be gasified for energy. This includes wood chippings, high density fibre (Almond), sawdust, e.t.c.

Palm Kernel Shells have very high energy content. In fact, two tons of Palm Kernel Shell is equivalent to 1 ton of diesel in energy contents.

Animal waste including poultry droppings, fish oil, etc. can all be used for power production. The latest technology for extracting oils from oil bearing seeds and animals is termed supercritical. It is very efficient and operates at about 70 atmospheres at 300°C.

For the production of one pound turkey meat 1½pounds of waste, 12000 tons of pig slurry plus 30,000 tons of food waste produces biogas for 800 homes in Europe.

In Minnesota, 55 mega watts of power are produced from poultry liter.

NUCLEAR: This option must also be looked at.

CONCLUSION:

It is important to explain that only a comprehensive approach to solving Ghana's problems will be viable. For instance, Tree Planting which is a forestation activity is the responsibility of the Forestry Department and theoretically has nothing to do with energy. Yet we realize that only this department can arrest the deforestation presently going on.

We have struck oil, yes, but the only way to prevent an oil curse is to go for the value addition chain in order to spread the wealth base.

We must use the biofuels for power and energy and multiply our revenue through a value addition chain of crude oil.

We must go in for meticulous planning with quantifiable targets, ingenuity, and endeavor, backed by uncompromising determination. FAILURE IS NOT AN OPTION!

CHAPTER VIII

AGRICULTURE:

In consonance with general belief that agriculture is the backbone of Ghana's Economy, Dr. Nkrumah adopted a comprehensive strategy for its development.

The program covered the establishment of commercial crops such as: Oil Palm, Coconut, Tobacco, Kenaf, Paper Pop Trees, Cola, Para Rubber, Cotton, Sugarcane, Citrus, etc. as well as arable crops, like Rice, Maize, Potato, Cassava, and Vegetables. He also paid attention to animal husbandry, i.e., Poultry, Piggery, Sheep and Goat and Cattle ranching.

For instance, tobacco was grown in the Volta and Brong Ahafo areas while Kenaf, the raw material for the manufacturing of jute bags, was grown in the Northern part of Ashanti and in major parts of the Brong Ahafo; these places were also famous for maize cultivation. Oil palm was grown in the Western Region and parts of Ashanti Region and also in the Eastern Region. Dr. Nkrumah's Flagship Project was the 22,000 acre rubber plantation near Bonsa in the Western Region.

Sugarcane Plantations were established at Komenda (Central Region) and Asutware in the Eastern Region. Both had sugar mills for the production of sugar. Cola plantations were established in the Eastern and Ashanti Regions. Even though Western Region was the natural home for the coconut, large tracks of land were acquired in the Central Region (Essakyir, Gomoa Adjumako) for coconut. Of the 22,000 acre projected for coconut planting only 2,000 acres could be completed before the 1966 coup truncated the project.

Dawenya near Prampram was famous for pigs and sheep. Large numbers of pigs were also introduced to graze under the oil palm trees in the Western Region. However, the Pigs turned wild and could not be controlled.

Ghana had the biggest stand alone cotton plantation at Zongo Machere in the Northern Volta area over 1,000 acres. This was done with the help of Soviet specialists. The plantation was to serve the Juapong Textiles. The project was also truncated as a result of the 1966 coup. A large area was cultivated to produce materials for paper production in the Western Region. Some specific agricultural projects are described in subsequent paragraphs. It is important to note that the projects were designed to link up vertically and horizontally with our agro-industrialization program. The State Fishing Corporation and Boat Yard were established to ensure proper attention for the fishing industry. Since Dr. Nkrumah believed in the knowledge-based technology driven strategy, even in those days, appropriate scientific research institution, e.g. Crop Research, Oil Palm Research, Industrial Research, Aquatic Biology, Animal Research, etc. were established to give scientific support to those projects.

RUBBER:

22,000 acres rubber plantation project in the Western Region was suspended. The actual program was to cover 75,000 acres within 15years. Farm plantation was given to Fire Stone of the U.S.A. on a silver platter—after payment of a pittance. The farm was deliberately undervalued and later taken away from the Ghana State Farms Corporation which had established the 22,000 acre project in about 4years. Even though Firestone had initially agreed to continue the project, it stopped further development after adding 2,400 acres in 4years, i.e. the same time the State Farms had spent in developing 22,000 acres. A 600 acre citrus plantation that happened to be within the enclave was taken free of charge. This was the second largest citrus plantation on the continent of Africa at that time.

Bonsa Tyre Factory, which was specifically established to use the rubber latex for the production of tyres and other rubber products,

was also acquired by Fire Stone. After managing the factory for a while, it alleged that the equipment from Eastern Europe was inferior. It dismantled the machines, brought a few American machines, then collapsed the whole project, making sure that Ghana had no capacity to make its own tyres and left.

At this point, it is important to note that even though the decision to transfer the project to Firestone was made at the time of the NLC (National Liberation Council) Government under General Ankrah, Dr. Busia was the chief political advisor to the NLC and all the Commissioners within the NLC became ministers under the subsequent Progress Party Government (PPG).

The late H.O. Wilson an Akuapem Royal was specially invited from Unilever Plantations of Nigeria by Dr. Kwame Nkrumah to establish the Rubber Plantation. During the meeting to discuss the value of the plantations, the Americans claimed that the quality of the planting material was inferior, a ploy to play down the value. It was at this point that Mr. H.O. Wilson was invited to testify to the good quality of the planting material which he had personally selected from the best planting material from Malaya now Malaysia. Despite the claim by the Americans that the planting material was poor, they were clearly heard by the Ghanaians as the Americans whispered amongst themselves HONEY! HONEY! HONEY! as they toured the farm. Yes, they have come upon honey in the west Region of Ghana. Yes, the Honey generated by Dr. Kwame Nkrumah of Ghana for Ghanaians was to be enjoyed by the Americans Firestone Corporation. This was the time when Dr. Kofi Abrefa Busia was the Chief Political Advisor to the NLC Government and all the commissioners (then Ministers) of the NLC Government were the ministers of the subsequent P.P. Government (Progress Party Government).

The Evidence is there and can be verified that the cumulative income from the 22,000 acre Rubber Plantations, in its life time (of 70 years) was sufficient to pay for all the money $400,000,000.00 (four hundred million dollars) or so?

Dr. Kwame Nkrumah was supposed to have inherited from the colonial government and alleged to have been "squandered" by him.

At this juncture, let me just list a few of the products that could have been derived from Rubber:

1. Dipped Latex Goods: Surgical gloves, balloons, condoms, etc.
2. ERAZER (RUBBER)
3. **HARD RUBBER BATTERY CONTAINERS:** also add reclaimed rubber.
4. **LATEX FOAM PRODUCTS:** upholstery material, pillows, mattresses.
5. **MICROCELLULAR SHEET:** Soles of shoes and sandals, wear tear resistant.
6. Oil RINGS (rubber) for sealing shafts and bearings made from dies and press heating.
7. **RUBBER BLOWING AGENT:** Reduces the bulk density of the sheet—light sponges.
8. **RUBBER ICE BAGS AND HOT WATER BOTTLES:** rubber molded products.
9. **RUBBER TO METAL BONDED PARTS:** e.g. Engine seats, oil seals for hydraulic systems of automobiles and presses.
10. **RUBBER MOLDED PRODUCTS/GOODS:** Parts in Railways, automobiles, bicycles—bushes, rubberized shock Absorbers, Rubber Rollers for printing machines.
11. **RUBBER THREAD:** lynched with readymade garment factory—for elastic tapes and fabrics manufacture from latex or dry rubber.
12. **RUBBER TUBES:** Uses—transmission of water, air, oil, steam and lubricant. Reinforced with metallic or cord wires for pressure hoses, etc.
13. **RUBBERISSED CANVAS HOSE PIPES:** Principle—Reinforces canvas cloth, rubber, latex coating
14. **RUBBERISED CLOTH:** Textile fabric coated with rubber for use in hospitals, homes and industry.

ADIDOME PROJECT/AFIFE/TADZEVU/OHAWU

ADIDOME:

This was a model farm project incorporating a large capacity mechanical workshop capable of totally overhauling 600 medium horse power crawler type tractors per year.

The complex included poultry with 20,000 birds, rice farm 1,000 acres, a dam capable of irrigating 3,000 acres of land, a 2ton/hr Satake Rice Mill, cattle ranch with a fence area of 500 acres separate from the 3,000 acre farm.

Evarite class B pipes were brought in from Russia for the project. The Pipes were to be used to bring water from the Volta River into the dam on site for the project. Evarite pipes are very strong high pressure pipes that could not be crushed even by a bulldozer. The project was to cover a minimum area of 3,000 acres as stated above. Special full track Russian combine harvesters capable of operating on flooded land without getting stuck were brought. In fact, high quality milled rice from Satake Rice Mill, sited opposite the Amelokope Animal Husbandry farm was in operation as at 1966/68. Satake rice mills were of Japanese design. They were very efficient and trouble free.

Equipment for milk processing had been brought as part of the complex.

A Farm Institute under the Ministry of Technical Education was set up on the adjacent property to help students acquire practical knowledge in Farm Mechanization.

My practical life as an engineer started from Adidome where I had to resolve great challenges.

My first major challenge was how to dismantle track plates of bulldozers in order to access the track bushings for replacement. Since this is very technical, I need to break it down. Bulldozers or Caterpillars as the ordinary man calls it, walk on big chains with plates or shoes attached to the chain. There are round bushes or links in the chain that are grabbed by the big teeth in the sprockets or gear resulting in the wearing of the bushes that need to be pressed

out before they can be replaced. This could only be done after the removal of the track plates or track shoes. These plates were bolted to the chain by four bolts to a plate. Due to the pressure on these bolts it was difficult to have them removed using spanners/wrenches. The normal practice was to use flame (oxygen and acetelyn gas) to wash off the bolt head.

On the average each track had 36 plates with 144 bolts and nuts costing 144 (old cedis) per track. Since the daily wage was about 50 pesewas (old cedis), this amount was equivalent to the monthly wage of 10 workers. In effect the amount spent on replacing two tracks per bulldozer could pay 20 workers a month.

To cut a long story short, I designed and built a mobile stand that made it possible to remove the bolt and to reuse them. Basically, the machine consisted of a 5hp (horse power) motor driving a gear box with a wrench. The heavy duty track was arranged in a horse shoe that allowed it to stand independently.

The equipment mounted on wheels could be adjusted to move on a vertical plane to allow the wrench to engage the bolt holding the plates. By locking the nut with the appropriate spanners, one could remove or tighten the bolts for dismantling or assembling by putting the intermediate gear box in forward or reverse position. This machine was built in 1968. Ten years later, Tractor Export, a large state enterprise in the then USSR had copied the equipment and was selling on the international market. The only modification made in their design was to change the position of the motor. My motor was mounted up while their motor was mounted down. Pulley and rope were used to move the gear box up or down in the vertical plane to hold the bolt in the track shoes while I used bolts and traveling nuts as in car jacks to move my gear box.

Crusading Engineer Robert Woode

(See extract of the Author's invention)

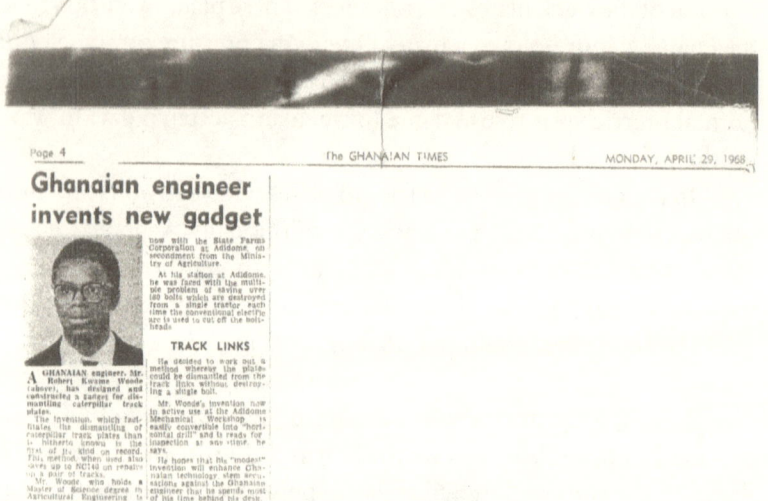

Adidome also taught me a great lesson about snakes as very intelligent species of animals.

It was a rainy day and I was driving an old jeep with canvas cover and removable plastic windows to Adidome poultry situated about a kilometer and half from my residence. En route, I encountered a large snake that was slowly crossing the road because it might have swallowed something and could not move fast.

I was young and adventurous in my early thirties. The Jeep had all its piston rings worn out and could barely move, may be 5mph. All attempts to accelerate failed. I barely missed the tail of the snake as it disappeared. To my horror and amazement, the snake had raised its body up and was dangerously looking for me to strike through the window of the Jeep. The vehicle was a left hand and the snake had crossed to the right hand side. I stiffined in my seat and from my right corner of my eye, I saw the snake frantically looking to strike. My luck was that the plastic windows were slightly dark making it difficult for the snake to identify me. At this time the Jeep's speed might have slowed to 3mph!

The point is how did the snake know that the vehicle was being driven by a human being and that human being must be held responsible for its threat on its life? It is about 40 years, but I have never forgotten it.

Anyway, this is a short deviation. Adidome workshop was one of the most functional machine shops in Ghana. It received various equipments, tractors, bulldozers, combine harvesters and other agro processing machines for rehabilitation from as far as Demon, near Yendi. Machine tools at that time were state of the art that gave us full capacity to dismantle complete tractors or bulldozers repairs/maintain and test them on modern test bench after repair to evaluate quality of performance. There was nothing near that anywhere in the country or for that matter anywhere in West Africa.

In fact, I urged the then Managing Director of the State Farms, Mr. H.O. Wilson to allow me to move the whole shop to Accra to help in the overall National Development Effort.

Adidome workshop attracted important dignitaries including the Israeli Ambassador who paid a visit in 1968 to look at the demonstration of the track dismantling machine.

As said elsewhere a similar workshop was being set up at Brenam near Wenchi, which was also to render engineering services to the Bui dam construction truncated by the 1966 Coup.

The machine tools—lathes, drills, shaping machines, and etc. mysteriously got burnt at Pokuasi where they were being kept awaiting transportation to Brenam.

TADZEVU/OHAWU

The Ohawu/Tadzevu cattle insemination project was established with the help of the Israelis to produce hybrid cattle and to accelerate large scale cattle production in the country. The project had housing facilities for junior and senior staff as well as a power station serviced by two 55Kva diesel electric plants to provide power for the fridges that kept the vile (semen), i.e. the materials for the artificial insemination.

AFIFE:

Afife had a much bigger area under rice cultivation and had two Rice Mills, a Satake Mill and an East German Rice Mill, the largest in the country at that time. Both projects suffered huge setbacks when the Russian specialists were unceremoniously sent away—another example of throwing the baby out with the bath water.

The potential of Afife to produce large quantities of good quality rice could not be ignored by the powers that took over after the over throw of Dr. Nkrumah. However, pragmatism was thrown overboard in deciding what was good for the project.

The rice farm was cited in a river basin and the land was wet almost throughout the year because unlike the north, the Volta Region experiences two rainy seasons.

The Russians therefore introduced special full track combine harvesters with very broad track plates that exerted little pressure on the field that made them move without getting stuck.

When the Russians were sent away, Class Combine Harvesters (German Made) with pneumatic tires were brought to Afife but could not work on the wet fields. The irony is that anytime they got stuck, the "bad" Russian Combines Harvesters were used to retrieve them.

About three seasons of rice harvesting were lost. After serious discussions with Engineers from Class Company, half track combines were produced specially for Ghana by the company. Half track means the front tyres were changed into bulldozer tracks. Unfortunately those ones also could not work. Since then Afife had never recovered from its low rice production after the exit of the Soviets.

DEMON:

Rice was also grown in the North at Demon near Yendi. Demon had large number of silos. All the projects were fully mechanized from land preparation, sowing, harvesting, drying to milling. Both

Adidome and Afife had large capacity mobile continuous dryers that could operate from 55 Kwa diesel electric generators.

Large quantities of locally grown rice were available up to the seventies until the P.N.D.C time when the State Farms Corporation was closed by the P.N.D.C Government. Some rice was also grown at Kwame Danso and Atebubu in the Brong Ahafo Region.

MAIZE:

The State Farms established maize farms in all the regions of Ghana. At one time Brenam had a 2,000 acre pure maize stand alone farm, the largest in the country at that time. Brenam is near Wenchi. It was a fully mechanized farm with maize pickers, threshers, cleaners, and dryers. A large shed was built to accommodate machine tools capable of fully rehabilitating 600 medium horse power crawler tractors. The workshop was also programmed to render engineering support services to the Bui Dam project. The requisite machine tools were kept at Pokuase as transit depot. The tools caught fire under unexplained circumstances after the coup. Maize was also grown at Adidome.

SUGAR CANE:

Two major sugar cane projects were set up at Komenda and Asutware, as part of nucleus farms established by the State Farm. The factories were serviced by many satellite farms owned by individual farmers and cooperatives giving employment to large members of families. The projects also gave rise to the establishment of many sugar cane crushing stations engaged in the distillation of alcohol. The two projects induced private sector interest in sugar production. At Mankensim, a young man by name Allan set up a private sugar factory and produced brown sugar with the support of Technoserve, an American NGO (Non Government Organization). The whole plant was designed and built in Ghana. Other entrepreneurs started importing small sugar production machines from India through Agricultural Engineers local company, for the production of sugar,

taking advantage of the involvement of many farmers in sugar cane cultivation.

The state-owned sugar factories started supplying by-product to the State Distillery for the production of alcoholic beverages reinforcing the concept of horizontal and vertical linkages that make economies strong.

After the Coup, in consonance with its precipitate denationalization program, the then government invited Tate and Lyle, one of the biggest multinational companies engaged in sugar production, to take over our sugar factories. It is 45 years now (2011) and even though many discussions with many other interested companies had taken place, nothing had materialized. As at now, the infrastructure equipment and everything linked to the project has become a very big loss. The two projects are now PILLARS OF SHAME for Ghana and maybe for Black Africa in general.

Sugar as we all know is an international commodity as in extensively used in the food and beverage industries. Its importance cannot be underestimated. Presently however, 60% of sugar production in the world is from fruit-base.

Fortunately Ghana has a lot of fruit varieties with high sugar content; these include pineapples, mangoes, water melons, pawpaw, bananas, etc. Information at our disposal indicates that it is much cheaper to produce sugar from fruit base than from sugar cane. Another plant that Ghana can look at as material for sugar is Sweet Sorghum. The advantage of this crop is that it produces edible grain as seed, while the stem contains sugar.

We must develop technologies that will help us extract sugar from cocoa sweating, i.e. the sweet liquid found in the jelly covering ripe fresh cocoa beans when the pods are broken to extract the beans. With dry cocoa beans reaching a million ton production, there is no doubt that large quantities of cocoa sweating should be available for sugar production and also for ethanol which can be used for running petrol vehicles. We extract sugar by concentrating the sweet liquid, i.e. evaporating the excess water and using a crystallizer to produce sugar crystals. In other words we need machines and equipment to produce the sugar.

Dr. Kwame Nkrumah always insisted that "organization decides everything." In other words we need a good plan to back the production of sugar in Ghana if we opt for the fruit base.

Fortunately, both the Eastern and Central Regions have suitable conditions for the production of the raw materials i.e. mangos, pineapples, pawpaw, water melons etc. Let us plan and act now. Our poverty is self imposed. We need clear targets as to when to stop importation of sugar as we produce our own.

The plan should make it possible to use the by-products as animal feed, after production of marmalade, jams etc. Pineapple crowns and banana stems should be retted for fibre to be woven into rope/thread then into bags, floor mats and also for the production of cardboards. Pineapple essence should be produced from peels. The plan should cover the full value addition chain of the materials. The CSIR should play a major role in this as well as organizing courses to empower the youth with necessary knowledge linking the project to the National Machine Tool Centre to replicate the necessary equipment for the entrepreneurs. My brothers and sisters, this is the way to take on the world by a Tsunami. Yes we can!

Kenaf—Material for Jute Bags:

Dr. Kwame Nkrumah realized that Ghana was importing millions of jute bags for bagging our cocoa for the export market. To save hard currency, the State Farms were commissioned to grow and produce large quantities of Kenaf in Ashanti and Brong Ahafo for the manufacture of jute bags. The farms were equipped with retting tanks to process Kenaf into fiber, sent to a well equipped jute factory in Kumasi for the production of high quality jute bags. To satisfy vested interests that always wished to keep Ghana down, Kenaf cultivation was undermined and subsequently stopped leading to the precipitate collapse of the Jute Factory and to facilitate the importation of Jute bags to satisfy those with the vested interest.

TOBACCO:

Ghana has been growing tobacco since Gold Coast time. Cigarette manufacturing was one of the projects that existed in the Gold Coast. A company by name TUSKER was in cigarette production at Kumasi owned by the Badussi brothers of Middle East extraction in the 1940's and 1950's. Since Tobacco was considered as an international commodity with good revenue, the State Farms were encouraged to go into it.

Tobacco was grown extensively in the Brong Ahafo and the Volta Regions. Large Tobacco barns for curing tobacco were put up in these areas and employed large number of people. Unfortunately, these projects started collapsing as a result of what one may describe as "State Indifference," leading finally to the disbanding of the process in an activity vaguely described as Divestiture which actually meant "close it and ignore it."

ANIMAL HUSBANDRY:

Dr. Kwame Nkrumah took great interest in animal husbandry i.e. Poultry, Piggery, Cattle and Sheep and Goat.

Realizing that the Tongu area of the Volta Region had similar climatic conditions for cattle rearing with the additional advantage of two rainy seasons as against a single rainy season in the North, Dr. Nkrumah decided to open up the Volta Region for large scale cattle production. Tadzevu, Ohawu and Adidome were selected for the projects.

An Israeli specialist with good knowledge in artificial insemination for cattle multiplication was invited to manage the project based at Tadzevu. High quality semen for artificial insemination was imported from Canada; A Ghanaian by the name Beckley was trained to do the job. As a result of this about 1,000 hybrid cattle was produced. Top management staff of the State Farms learnt that the government was trying to divest the cattle as it had previously done with the Rubber, which subsequently deprived the State Farms of good revenue, the cattle were quickly moved to

Kwamoso in the Eastern Region where the State Farms had a 2,000 acre Oil Palm Plantation, for the cattle to graze on the santrocema cover crop rich in protein.

It is sad to know that the whole herd of cattle disappeared during the P.N.D.C time together with about 500 cattle at the Demon Farms near Yendi.

The situation at Adidome was more bizarre. There was some information that the Russian cattle were not suitable for Ghana. One cattle was killed every week and the meat sold for 10pesewas a kilo those days. I must admit I ate some. Well, if you can't beat them, join them. In any case, I did not have enough power to stop this in 1966. A milk production project earmarked for Adidome and Klukpo—a Worker's Brigade cattle Farm near Adidome was suspended and never took off until the State Farms were closed down.

One immediately realizes that the cattle project at Tadzevu, Ohawu, Adidome and Demon were horizontally and vertically linked to the Bolgatanga Meat Factory, Aveyime Tannery (converting skin into leather), and the Glue Factory in Kumasi (horn and the bones of cattle melted into glue). Kumasi Shoe Factory and the Rubber Factory in the Western Region which was to provide rubber for the sole of the shoe; It is obvious that those blaming Nkrumah for setting up the Bolgatanga Factory without cattle were just uninformed.

In any case, there was an existing agreement with Upper Volta which specified that certain quantity of cattle were left in the country anytime the cattle came to Ghana to graze. The corned Beef Factory was never short of meat during Nkrumah's time.

PIGGERY:

Dawhenya was the largest farm for pig rearing in Ghana. Many people associate Dawhenya with irrigated rice farming. This is true. However, rice farming was not the principal activity. Pigs were also reared at Pokuase and Amelokope near Adidome.

There were interesting experiences learnt during the implementation of this project. The most exciting were the frequent

fights between snakes and pigs. Dawhenya piggery always attracted large numbers of rats who came to share the pigs' food; The presence of rats naturally attracted large snakes. When the snakes miss the rats they target the defenseless newly born piglets.

We used to go to the piggery to watch those frequent fights. In all the encounters that we watched, the snakes always lost and were finally eaten by the pigs.

The secret is that because of their fat the snake's venom does not penetrate the pig's blood stream. Moreover, pigs are group fighters like dogs, so they easily overcome the snakes.

Dawhenya piggery was the main supplier of piglets for rearing by pig farmers. The overthrow of Dr. Kwame Nkrumah and the subsequent collapse of the State Farms dealt a heavy blow to the piggery industry.

Plans for mincing pork into sausage were abandoned.

POULTRY:

This was a major activity of the State Farms. The Poultry sector had its head office at Odorkor near Dansuman and popularly called Akuko Photo. This was because there was a large billboard at the Kaneshie Odorkor Junction of a large bird brooding over an egg. Odorkor Poultry was the largest in Africa during the time of Dr. Nkrumah. The farm had a feed mill, hatchery for day old chicks, machines for dressing birds, cold store etc. The next biggest poultry was owned by K.A. Gbedemah and situated at Adidome. This project was famous for the production of chicken oil.

Ghana was self-sufficient in poultry products because there were large poultry farms also at Afife, Adidome, Kwadaso, Kentenkronu, Kpeve, etc. Eggs were always thrown away because of frequent gluts. A crate of eggs went for about 55 pesewa being a full wage of a worker at that time.

A very large poultry farm complex directly under the Ministry of Agriculture was under construction at Pomadze near Winneba. It must be explained that the Director of the State Farms was very powerful member of cabinet. His position was equal to that of a

Minister. His name was Atta Mensah and doubled as a member of the C.P.P Central Committee. The fact that Mr. K.A. Gbedemah had his own private poultry as well as others, clearly indicated that, Dr. Kwame Nkrumah was not a communist. Odorkor poultry was also famous for its Turkeys.

The State Farm Poultry projects collapsed when the corporation was closed down in 1981 and put on the divestiture program.

FISHING:

The establishment of the State Fishing Corporation with fishing vessels, boat yards and fishing harbors as well as cold stores demonstrated the extent of Dr. Nkrumah's interest in the Industry. Ghana had good fishing vessels that could travel as far as to Angolan waters to harvest fish. In accordance with Nkrumah's program of horizontal and vertical integration of industrial activity, Tema Food Complex was established to can the fish and produce fish meal as by-product for the poultry and the piggery industry.

Like the other state industries, they also suffered precipitate denationalization instead of programmed and gradual denationalization as was done by the Chinese. At this juncture it is important to draw attention to the Soviet Union's approach during its privatization program. Unlike the Chinese the Soviets chose the precipitate approach just as Ghana did. This is why the Chinese economy is now much stronger than that of the Russians, even though the Russians had a much stronger economy than the Chinese before they both embarked on denationalization program.

TEMA FOOD COMPLEX:

The Tema Food Complex was one of a number of agro processing factories including Nsawan Cannery, Golden Oil Mill (for groundnut oil), Essiama oil (for coconut oil), the Bolga Meat Factory, the Tomato Canning Factory etc. This factory was refurbished at a high price and sold to foreign company at a price

lower than the refurbished cost. Yes, strange things can happen in this country!

The project was also one of the major flag ships of Dr. Nkrumah designed to fulfill the role within a value addition in agro processing.

The factory specialized in grain processing—wheat into floor and its by products for animal feed, corn also into flour and its by-products; vegetable oil seeds—into refined vegetable oil and its by-product for animal feed, fish into fish meal and fish oil.

It also had one of the largest cold stores to help store fish from private and public sources. It was also designed to receive students from polytechnics and universities for attachment and acquisition of practical knowledge to empower the players to set up similar projects in the same way has been done by the Chinese.

Can anyone imagine the knowledge that could have been in Ghanaian hands if we had ran those projects from 1966 till now?

Would that knowledge not have helped us to replicate the equipment under the leadership of the great Osagyefo? Did the subsequent leaders ever think about this? Could they quantify the value of that knowledge and match against the so called financial losses that Dr. Nkrumah's Government created? Yes those who quantified so called Nkrumah's financial losses without the full socio economic/technological impact of the project are certainly little minds.

I want to hear them put value on the knowledge acquired by those Ghanaians who trained in the higher institutions both inside and outside Ghana in those days.

Let them tell us what they did with such people when they took over the country. Let them compare state of Knowledge and availability of such specialist:—Doctors, Engineers, Architects, Artisans during Nkrumah's time and their time.

If Dr. Kwame Nkrumah had only half the specialist's technocrats in 1957 that subsequent Government inherited, we would have seen a totally different Ghana. Let them not waste our ears. The Akans say "If you cannot carry the load, then you blame the head pad."

I want to remind them again that Koreans did not have half the type and number of technocrats Dr. Kwame Nkrumah had created by 1966, yet look at what the leadership did when the race started in 1966.

Ghanaians please open your eyes!

MISCELLANEOUS FACTORIES:

Apart from miscellaneous rural factories processing cane, fiber and bamboo, we had major factories such as the Kumasi Shoe Factory that supplied booths for the security services and the Saltpond Ceramic Factory that produced toilet sinks, bath, etc for the State Housing Corporation and insulators for low voltage electricity. Ghana also had marble works.

At this juncture I wish to make a special mention of the coconut fibre processing plant sited between the first and second entrance to Saltpond on the Accra-Takoradi road. The factory was designed to process coconut fibre for the 22,000 acre coconut plantation to be established between Essarkyir and Gomoa Adjumako. The factory was receiving coconut husks from Western Region and Central Region at the time of the Coup.

The factory could also process fibre from pineapple crowns and plantain and banana plants.

Among its products were marine rope, floor mats and door mats.

I wish again to state that natural fibre has large international market. Fibre mixed with heavy density plastic produces a spongy material useful as insulation for buildings and also for car seats and many other applications.

There are also international markets for natural fibre as mulching materials for farmers in Europe, Canada and America. This country has indefinite sources of fibre from miscellaneous plants growing wild.

Our people can use natural fibre for making sacks and decorative bags if they are empowered by appropriate organizations. This kind of empowerment must be led by the State in a programme. This is

one of the things done by the Indian Government to empower their people. This can only happen if we have a national development programme.

Entrepreneurship means nothing if the people are not empowered. This nation cannot be developed by entrepreneurs who are not empowered as preached by little minds.

You can only have a few naturally gifted people that create wealth through entrepreneurship. The player must know what to do and how to do it before he becomes an entrepreneur.

Moreover his product must fit within the national development agenda before it can become sustainable and effective.

Can we imagine what will happen to natural fibre producers if we make a law forcing all new houses to incorporate natural fibre mixed with plastic to insulate houses from external heat to cut energy needs?

Can we also imagine the effect if new houses are forced to incorporate solar water heaters as in Israel and Chimneys (sometime called wind towers) to suck out heat from rooms as in Australia and the Middle East and rain harvesters? Can we imagine the new jobs that can be created as well as energy savings?

DO NOT LEAVE THIS COUNTRY TO LITTLE MINDS. Ghanaians!!!

CHAPTER IX

THE POTENTIALS OF INDUSTRIAL MINERALS

Our minerals can roughly be grouped into two:

a. Ore minerals consisting of Gold presently found everywhere apart of the traditional places like Obuasi, Tarkwa, Prestea

Diamond found in Akwatia, Oda etc. manganese at Nsuta and Bauxite at Awaso, Nyanahin, kyebi etc.

b. Industrial minerals consisting of Silica Sand, Kaolin, Talc Phosphate Rock Clay, Feldspar, Barite, Salt, Limestone, Dolomite, Jasper, Beryl, Betonies, and Granite etc. have been neglected.

At the time of writing (2011) large quantity of uranium have been found for the production of nuclear energy.

It will be recalled that only Dr. Nkrumah's Government made a determined effort to utilize our silica sand for the production of glass ware at Aboso Glass Factory and the production of sanitary wares, refractory products, porcelain etc. through the now defunct Saltpond Ceramics in the Central Region.

The Brick and Tile Factory at Odorkor and the marble works not far from the State

Transport Headquarters have all collapsed because of the precipitate denationalization programme embarked upon by subsequent Governments (we have PP-Progress Party, PNDC, the NDC and NPP).

HOUSING PROJECT:

The State Housing Corporation was established to build houses for the population. Within the short span of existence, it built Njaneba Estate, Labone Estate, Teshie/Nungua, Keneshie, Ringway, Kanda Estate and finally a new Tema Township in conjunction with the Tema Development Corporation. To accelerate the housing program; a new organization was established with the Russians to build houses using prefabricated panels at the Kaneshie Industrial Area.

Dr. Nkrumah's housing programme created a cadre of highly professional architects and draftsmen who produced detailed drawings of the houses that were built. It is obvious that if the state housing had not been allowed to die, this country by this time would have had great capacity in housing design and erection.

I believe the corporation would have been building houses in West African countries just as the Chinese and the Koreans are doing now. We need to remember that the Koreans did not have professional architects and draftsman in the sixties. I am making this statement on authority. We have allowed the water to pass under the bridge. We can't go back those strategies. The Koreans have overtaken us and they are now going to build houses for us as at the time of writing (2011).

From table 2 social/statistical information basic data below, Ghana's population in 2010 is estimated at 25,335,400. This represents about 500% increase over the early sixties. Meanwhile, the surface area of our land has been the same because God is not creating any more land. This simply means we cannot use the same strategy—horizontal housing development. We have to go up—vertical high rise buildings. We must also move with the times—the need to build more environmentally suitable houses to

save energy. We can reduce temperature in our rooms by introducing insulation materials—natural fibre mixed with plastics into walls. We need to design houses with ventilation ducts that end in chimneys as stated elsewhere in this document, solar panels and wind towers (Chimneys) must also be looked at. This should cut down the use of air conditions and fans. Each house must have rain harvesting gutters and reservoirs to supply water for washing and for toilets and also solar water heaters.

Upgrading the Aboso Glass Factory to produce fibre glass will help us manufacture fibre glass roofing sheets, minimum life span 50 years for our houses. The housing infrastructure must be complete with recreational areas, medical sites, supermarket and green areas for recreation.

Finally it will be in the overall national interest if we do not attempt to solve the housing problem in isolation. It is absolutely important that the problem is considered within the frame work of the National Development Strategy. This will ensure that all our development activities are vertically and horizontally linked with quantifiable targets to ensure accountability and reduce fraudulent practices. Let us remember that apart from the raw constructional materials, a housing programme must link with water supply, electricity net work, sanitation, road network, schools/education infrastructure, market centers and efficient transportation, all of which may fall under different ministries.

STATE CONSTRUCTION COMPANY (SCC):

The S.C.C. had 122 sites spread over the country and was involved in large construction projects—bridges, large properties, such as silos, big factories and major roads. The State House commonly called Job 600 was one of the iconic projects executed by the S.C.C. The name 600 emanated from the fact that it was the 600th project of the S.C.C. In fact, the S.C.C. started receiving contracts outside Ghana.

The corporation had very good Ghanaian artizants, craftsmen, architects, and first class Engineers. It had its major site at Abelenkpe,

equipped with the largest assortment of workshop tools second in size only to the Ghana Railway Location at Sekondi.

At the time of writing (2011), SCC had been closed down for 18years and only one of the 122 projects had officially been divested. The place has now been turned into a skilled training centre for tailors and seamstresses. The rest of S.C.C. projects nationwide had been allowed to rot away. The equipment including: Graders, Heavy Duty Tipper Trucks, Asphalt Layers, Miscellaneous Mechanical Loaders and Diggers, etc. has recently disappeared. Workshop machine tools-Lathes, Drills, Milling Machines, Boring Machines, Crankshaft Grinders, Forging Presses, Foundry, Sheet Metal Rollers and Benders as well as Shearing Machines, Tool Grinders, etc. were still there at the time of writing. How can anybody explain or justify this? The period covered 8 years of NDC (1)—J.J Rawlings and 8 years of NPP rule and then presently 2 ½ years of the NDC (2)—Atta Mills.

The truncation of these projects made it impossible for the original craftsmen, artisans and various administrative staff to transfer their hard won knowledge and experience to the next generation. This has created a serious generation gap of these kinds of players in our National Development effort. A gradual denationalization and structured process would have prevented this. Let us hope that those who took those decisions are conscious of what they have done to this country. Let us also remember that no Ghanaian company would have had the capacity—financially and in terms of manpower to have undertaken those projects executed by the SCC. The establishment of SCC was part of the National Empowerment Process, the same structured development strategy that has allowed the Chinese to be where they are now. The irony here is that we disbanded our state construction company and employed the Chinese counterpart in China to undertake similar projects here.

NATIONAL TRANPORTATION STRATEGY:

Dr. Kwame Nkrumah had a comprehensive transportation strategy involving: 1. Air Travel (Ghana Airways), 2. Road Transport and Haulage (State Transport) for Personal and Cargo, River Transportation (YAPEI Queen of the VRA), International Shipping (Black Star Lines), Omni Bus and State Taxis running within the cities and towns.

The Railway system was very efficient and actually provided the largest revenue to meet the salaries of the civil service in the 1950s. Ghana had express Rail Service between Accra, Kumasi and Takoradi. This was called the Blue Train. It ran on time and it was very efficient. Subsequent governments collapsed this service. The bulk of our cargo—timber, bauxite, manganese, cocoa, shear nuts, fuel, tiles etc. were all carried by our railways which were supported by a training school and a large workshop named the LOCATION, which ensured efficient service.

Dr. Nkrumah proposed a program to link Accra to Tema by ELECTRICAL RAIL SYSTEM. I saw the plan myself at the office of VRA in Accra in 1966. Interestingly the top management staffs of all these organizations were Ghanaians.

The Tema Motor Way was designed to link Kumasi and Takoradi in what was described as the Golden Triangle. That was also truncated! During Nkrumah's time the motor way was fenced fully and no one could access it from the sides. It was equipped with radio telephone at one mile intervals for emergency calls in case of accident.

THE STATE TRANSPORT:

This was the leading transport organization on the West Coast. Locally the organization provided a reliable and efficient transport service between major cities and towns in Ghana. It also ran services within the West Africa Sub region. The Cargo section had its head office in Tema and was backed by a reasonably equipped workshop, while the passenger service was in Accra also with a well equipped

workshop. Like the Railways the staff was totally made of Ghanaians. The organization had assets including buildings in the West African Sub region. All these assets have virtually been looted.

STATE TAXI:

The State had clean well maintained and metered Taxi Service in Accra. This is no more yet one can say without fear of contradiction that such a system still exists in India presently, parallel with private sector run services. It was a joy to see taxi drivers in those days dressed in white-white apparel. The taxis were metered.

MUNICIPAL BUS SERVICES:

These services were available and run efficiently during the time of the CPP Government. School children had free ride on those buses.

AIR TRANSPORT—GHANA AIRWAYS:

This was a colossus in the west coast. It provided the most reliable and efficient Air Transport Service in the sub region. In addition, Ghana had a very reliable Internal Air Service covering, Tamale, Kumasi, Sunyani, and Takoradi. It had the best service connection from the West Coast to London, Germany and North Africa. Among exclusively Ghanaian pilots, was the first African female pilot, the mother of Dr. Angela Ofori Atta, a former Deputy Minister of State in the President Kufours' government. This state of progress made the Ghanaians proud.

TEMA DRY DOCK:

This was built as part of the infrastructure for successful running of the maritime industry. The primary aim was to service the fleet of ships of the Black Star Line, The Navy, and also to take advantage of the absence of any such facility on the West Coast and to induce

the construction of ships by Ghana. Despite its great economic importance the project has been allowed to run down. It is now one of the many pillars of shame for this country. The main dry dock has the capacity for accommodating 100,000 ton vessels.

Certainly this was a big facility considering what was in existence in those days, elsewhere in the world.

The project has now been handed over to a Malaysian company. On the 14th of October 2008, I personally paid a visit to the dry dock with some staff from the National Investment Board a representative from the office of the President and the Executive Secretary of Association of Ghana Industries (AGI) and had discussions with the then boss who was a retired Admiral of the Malaysian Navy. He appeared enthusiastic and committed, and God willing Ghana may see a new and modern dry dock by 2013 as at now 2011, the prospect did not seem to be what had been anticipated yet this is the time we need the dry dock most because of the discovery of oil and the concurrent introduction of large Rigs and oil tankers.

As at 2011, no serious steps had been taken to address this untenable situation. If Ghana had paid proper attention to the dry dock project, the boatyards and the petroleum refinery in Tema, we would have had the capacity to manufacture the Ephaso Offshore Drilling Refinery instead of relying on imported vessel. The establishment of an Advanced Machine Tool Center would have facilitated this project.

GHANA ATOMIC ENERGY COMMISSION (GAEC)

This center was established when many European Nations had not even thought of putting up such projects. It is certainly one of the first such projects in Africa established with the help of the USSR.

At the ceremony marking the laying of foundation stone for the Atomic Complex on 25th November, 1964, Dr. Nkrumah said:

> "Our sole motive in reaching the decision to build
> the Centre which you now see rising before you, is to

enable Ghana to take advantage of the decisive methods of research and development which mark our modern world. It is essential to do this if we are to impart to our development that acceleration which is required to break even with more advanced economies. We have therefore been compelled to enter the field of atomic energy, because this already promises to yield the greatest economic source of power since the beginning of man."

It has the following divisions:

National Nuclear Research Institute (NNRI)
Biotechnology and Nuclear Agriculture Research Institute (BNARI)
Radiation Protection Board (RPB)
Radioactive Waste Management Center (RWMC)

The center caught fire under very strange circumstances not long after the 1966 Coup. Israeli Radio announced the fire before Ghanaians were even aware. In view of the importance of the project it was expected that a fact finding committee would be set up to investigate the fire outbreak and to take steps to safeguard the property from further damage. However, this never happened because some foreign advisors had recommended that the project be dismantled. Sometimes Ghanaians just amaze me. How can anybody request a competitor in this case an exploiter who has been exploiting you from time immemorial, to advise you on an endeavor that is likely to give you the capacity to compete him?

As a result of recommendations made by some British Consultants the original programmed activities were drastically scaled down. The Soviet Scientist were sacked and deported and the project suffered serious setbacks. All construction works including staff accommodation were suspended and the projects deliberately run down, until recently when some Chinese specialists were brought in to reactivate the programme. What we have presently is

a mere shadow of the original plan, that is, both in terms of the size of the reactor and the scope of activities.

The sad point is that, for the 19 years that ex-President J.J. Rawlings was in power he never visited the Atomic Energy Commission neither did the ex-President J.A. Kufour during his 8 year rule.

SCIENCE AND TECHNOLOGY:

Dr. Kwame Nkrumah created the National Research Council (NRC) in 1958 less than one year after independence in 1957 with him as Chairman having fully recognized the need to explore Science and Technology to provide a scientific basis for development. He founded the Ghana Academy of Science at the launch of the 7year Development Plan of 1963/64—1969/70. The Plan stated among others: "THE PLAN provides the blue-print for the future progress and development of Ghana as a nation. It is a program of Social, Land, Economic Development based on the use of Science and Technology to revolutionalize our agriculture and industry."

As a result of recommendation made by the Cockcroft Committee set by the National Liberation Council (NLC) Government to advise on the future of the Ghana Academy of Science after the coup in 1966, the Academy was split into

(I) Ghana Academy of Arts and Sciences and
(II) Council for Scientific and Industrial Research (CSIR).

The Council for Scientific and Industrial Research (CSIR)

The organization comprised of the following:

1. Animal Research Institute (ARI)
2. Crops Research Institute (CRI)
3. Food Research Institute (FRI)
4. Institute of Industrial Research (IIR)
5. Water Research Institute (WRI)

6. Building and Road Research Institute (BRRI)
7. Forest Product Research Institute (FORIG)
8. Science and Technology Policy Research Institute (STEPRI)
9. Oil Palm Research Institute (OPRI)
10. Savannah Agriculture Research Institute (SARI)
11. Plant Genetic Resources Center (PGRC)
12. Soil Research Institute (SRI)
13. Institute for Scientific and Technological Information (INSTI)
14. Cocoa Research Institute (CRI)

The Cocoa Research Institute which actually was born out of (WACRI) West African Cocoa Research Institute was set up by the colonial government to support the cocoa industry.

As stated earlier, Dr. Kwame Nkrumah was the Chairman of the National Research Council (NRC), the grand parent of CSIR because he believed in the application of Science and Technology as the main tool for driving the economy even in those days in 1958.

Since the institution was more or less the "Darling Baby" of the President it was deliberately ran down when the coup occurred. CSIR staff suffered underserved humiliation and has never recovered since then. At the 50th Anniversary Celebration held at the Head Office of the organization (**May 2008**), the Deputy Minister of Education Sports and Science, Miss Elizabeth Ohene, speaking on behalf of Government demanded that the "Institution should justify its existence." Unfortunately, this has also been the position of the previous NDC Government (NDC 1 under J.J Rawlings). This is a great shame.

The scientist is a TOOL to be used for development. It is like asking the screw driver or a needle or even a key to justify their existence. The representation of a junior minister who does not attend cabinet meeting, at the 50th Anniversary of the CSIR an organization set up and chaired by the great President of Ghana Dr. Kwame Nkrumah shows the degree of commitment to Science and Technology Development in Ghana. This is all the more unfortunate if it is now accepted that the POVERTY GAP is a (Science) and TECHNOLOGY GAP.

Presently the CSIR is in a state of permanent "Eclipse." Laboratory equipment, tools and general facilities require refurbishment. Staff morale is low and if this is the state of our main tool for driving this economy then Ghana should forget about development.

It is advisable to note that between 1999 and 2001 SOUTH KOREA established 22 new and additional Scientific and Engineering Research Institution bringing the national total to 83. The GDP of that country shot up by 96 billion dollars at end of the program.

You will also recall that when Adolph Hitler wanted to conquer the world he asked his scientists to give him the most modern fighting equipment: the Jet Plane and the Ballistic Missile. He prepared the enabling environment and the scientists proved their worth.

I challenge you, the reader, to identify just 6 out of the 18 products from Neem Tree, four from pine apples and also five minerals apart from Gold, Bauxite, Manganese, and Diamonds. Our people cannot identify the commonest plants around us nor their value addition chain and how to extract their potentials.

Our scientists have a great role to play in our National Development Agenda. It is up to the State to use them as a trainer of trainees in predetermined areas of wealth creation.

TERTIARY INSTITUTIONS:

Dr. Kwame Nkrumah, appreciating the importance of Scientific Knowledge immediately set up KNUST, University of Cape Coast (UCC) and programmed the establishment of an Agricultural University in the Volta Region. I was personally interviewed in 1966 at the Police Headquarters on whether the program, i.e. the establishment of the Agricultural University in the Volta Region, should continue. Even though I advocated for the continuation of the project which was ready to take off the N.L.C. government abandoned it.

Construction of Cape Coast University was suspended for a long time after the 1966 coup. KNUST appears to be going off its

core engineering activity. The limited facilities are now shared by other non engineering faculties. This is sad and must be stopped.

Dr Kwame Nkrumah set up the Medical School. However, since this Institute has had no adverse problems we can ignore it. Other skilled training centers and polytechnics are also not too adversely affected so they are being left out in this discourse. KNUST was built before South Korea built a similar Institution that catapulted the country into technological advancement. Ghana lost engineering focus after 1966 Coup.

However one cannot ignore the special contribution made by Takoradi Polytechnic to the economy of Ghana. The Institute has produced first class professionals and technocrats who have impacted very positively and strongly on the economy. The absence of clear economic objectives with quantifiable targets by the State has not made it possible for the nation to take advantage of the specialists.

Another major problem is also the absence of an Advanced Machine Tool Centre that would have been used as a platform for the granduants to lift this country up. Their situation has been worsened by the total collapse of the engineering manufacturing base. Dorman Long or D.L. Steel which used to be the leading Engineering Production Company in Ghana has now been closed down and the premises turned into a church; so are the Agriculture Engineering Company as well as A&B Industry and many other similar engineering companies in Accra.

GHANA MEDICAL SCHOOL:

Ghana Medical School was established by Dr. Nkrumah at a time when everybody thought that it was not possible. Through persistence and what I would also describe as uncompromising determination, the School was born on about 1962/63. All the main players of that endeavor were Ghanaian doctors selected by Dr. Kwame Nkrumah and upgraded to professorship status by Executive Instrument. It is really satisfying that the Institution has been allowed to grow and now ranks as one of the best in the sub region.

WINNEBA IDEOLOGICAL INSTITUTE:

The principal objective of the organization was to ensure proper national orientation and for the trainees to understand the political forces at play in the international arena.

The doctrine of self reliance and self belief was also a key factor in the programme. Good discipline and patriotism were some of the important subjects that received serious attention within the curricula.

The Ideological Institute had very close linkage to the Sports Training Centre also established at Winneba because Dr. Nkrumah believed in "Mens Sana in Corpore Sano"—a sound mind can only be found in a sound body. Unfortunately, the Institute suffered the same fate as many other projects of Dr. Nkrumah, i.e. thrown out together with the bath water. Certainly such an institution would have been a good tool for the National Reorientation Programme embarked upon by the Kufour presidency.

THE MARITIME TRAINING SCHOOL AT NUNGUA:

It is heartening to know that this Institution established by Dr. Kwame Nkrumah to support the Maritime Industry has attained a very high status serving not only the needs of Ghana but the whole sub-region. At the same time it is sad to know that both the Black Star Shipping Line and the State Fishing Fleet which were to benefit from this institution have all been allowed to collapse prematurely by successive Governments after 1966.

AFIENYA GLIDING SCHOOL:

This Institution was established to generate interest in gliding by the youth. Of course the overall objective was to produce excellent pilots. It was headed by one of the world's top female pilots who worked closely with Hitler of Nazi Germany.

The Afienya Gliding School has been downgraded and no training in gliding takes place anymore. This is yet another example

of throwing the baby out with the bath water. It will further be recalled that large numbers of Ghanaian youth were sent to the USSR to train as pilots and aircraft maintenance engineers. Unfortunately, most of the students were recalled after the 1966 coup and those who trained and qualified were just ignored. Most of such people succeeded only by changing their professions.

NATIONAL LOTTERY:

This is one of the most ingenuous projects designed to mobilize funds for National Development. The organization generated huge revenues to the Consolidated Funds to support the national budget. Unfortunately, through various manipulations this role has been drastically reduced to the detriment of the national economy.

AGRICULTURAL DEVELOPMENT BANK:

This was established with the main aim of providing funds for accelerated development of Agriculture. It provided funds for agricultural related activities nationwide. I am not sure whether the clandestine design to sell this to the South Africans is going to be implemented.

STATE INSURANCE CORPORATION (SIC):

Realizing the important role of the insurance industry in national development as well as its great capacity for mobilizing funds, Dr. Nkrumah established the State Insurance Corporation and insisted that the State Assets as well as organizations depending on the consolidated fund, insured with the SIC. These steps made it possible for the organization to establish a large network over the entire country within a very short time and actually became the leading insurance company in the whole country. Financial resources from SIC have been used to support many state projects. It also serves as a trainer of trainees of those Ghanaians who subsequently set up their private insurance companies.

SSNIT: {Social Security and National Insurance Trust}

This was also set up by Dr. Nkrumah to ensure that workers would not become destitute after retirement. Under the scheme both the employer and employee had to make compulsory contribution to the fund which would then be assessed by the worker after retirement or premature death by his next of kin and also in case the worker became incapacitated through an accident or any other mishap.

SSNIT became one of the richest organizations in the country. The Social Security Bank was actually established using non performing financial assets of SSNIT. Funds from SSNIT have been used on many occasions to finance many governments' programmes and activities as well as many private enterprises.

SSB BANK:

This was setup using the non performing financial assets of SSNIT. It was totally owned by the state but now has been divested to a foreign company. Ghanaians must have to decide if the action was prudent or not.

BANK OF GHANA:

The Bank of Ghana was established by Dr. Kwame Nkrumah to supervise all other Banks and to regulate financial transactions in such a way as to protect the Ghana currency. It is the only bank with power to issue currency and was mandated to ensure the stability of the currency. It was also the custodian of Consolidated Funds and all incomes such as donor support and taxes from mining, construction, and minerals, etc. and it established the proper relationship between the Ghanaian currency and other currencies. It was also responsible for all Government cheques, bonds and all State investments made through the Bank of Ghana.

NATIONAL INVESTMENT BANK (NIB):

Dr. Nkrumah established the National Investment Bank using the assets of the defunct I.D.C (Industrial Development Corporation) set up the British Colonial government in 1948 to promote the Industrialization of Ghana. It played a major role in funding very important projects in Ghana. I.D.C. was the first state enterprise established in Ghana. This shows that Dr. Nkrumah did not start state enterprises. It was set up by the British in accordance with existing trends worldwide.

GHANA COMMERCIAL BANK:

The Ghana Commercial Bank was also established by Dr. Kwame Nkrumah to support public servants and private individuals and also to assist local entrepreneurs who required financial assistance for commercial activities. Ghana Commercial Bank could be found in virtually every town in this country. It had over 104 branches nationwide and has contributed immensely to the banking industry in Ghana.

Fortunately, it has managed to resist all attempts to privatize it. This is an example of properly run State Enterprise. However, its offices in Togo and Britain have been closed. We are not sure of what happened to those assets.

GOLD REFINERY TARKWA:

This is also one of the iconic projects of Dr. Nkrumah to take full advantage of our gold resources and its major by-products platinum.

The project was about 95% complete when the Coup occurred. Can anybody imagine the impact on this economy if we had a functioning gold refinery when Gold price shot above $800.00 per ounce? It is 42 years since the project was abandoned, yet none of the succeeding governments has expressed any desire to reactivate it. This is a good example of throwing the baby out with the bath water. As of 2011, the price of gold is about $1,800.00 an ounce!!!

CONCLUSSION:

Dr. Nkrumah's activities covered all areas of national endeavor—electronics, steel works, cement, commerce (GNTC), housing (State Housing Co.), pharmaceuticals, food (Tema Food Complex), Nsawan Cannery, and Bolga Meat Factory). Stationary Printing, Glass Factory, and Ceramics, Leather, Boat Building, Textiles (Juapong), Crude Oil Refining, Telecommunications, Hotels and Guest Houses etc.

The implementation of these programmes resulted in weaving together the people of Ghana into one unit. Ghanaians saw themselves more or less as colleagues of SCC, Workers Brigade, and Gihoc etc. pursuing the common objectives of economic emancipation of the country. There was no room for tribalism.

He was aware that capitalism could not be built without capital and that the people also did not have the knowhow and the technology needed for industrialization by individual entrepreneurs. Putting the State in the driving seat to initiate such programme was the only sensible option.

The Chinese have used the same method to reach where they are now.

The Chinese success has totally vindicated Dr. Nkrumah. The crash of financial institutions in the U.S. and the world at large proves that the market place does not guarantee a level ground for economic sustainability. **It is also true that no developing country has successfully moved itself from economic backwardness to prosperity on the back of free market forces.**

About 200 years ago one Edmund Burke a U.S. philosopher said **"A State without the means of some change is without the means of its conservation."**

It is obvious that the Chinese success has their roots in this statement.

A developing state cannot leave its future in the hands of "Market Forces" dictated by advanced countries!

CHAPTER X

THE CONTRIBUTION OF THE PRIVATE SECTOR TO POVERTY REDUCTION

PRIVATE SECTOR:

What does the Private Sector stand for in the context of Ghana's Economy?

Information emanating from both the International Labour Organization (ILO)

Ghana and the Private Enterprise Foundation Ghana indicate that 70-80% of Ghana's Private Sector is categorized as <u>informal.</u>

In the January 2005 Sessional Address to Parliament, President J.A. Kufour described this sector as a group of individuals and enterprises that are unable to keep pace with modernity.

He further elaborated that the Sector encompasses a host of activities including agriculture, commerce, manufacturing, construction and entertainment.

Furthermore, at a presentation on the topic Policy Dialogue on Poverty Reduction and Wealth Creation in the Informal Economy held on Tuesday, 1st March 2005 at Cresta Royale Hotel, Accra, (The Author was also present at the presentation) the Director General of P.E.F.—Private Enterprise Foundation said "The informal sector is an unstructured, high risk, chaotic system. Success in the Sector is highly selective and may not be due to predictable or verifiable factors. Because of the underlying challenge of survival, informal

sector operators do not respect, follow or apply rules and regulations consistently."

It came out from the same presentation that the informal sector has the following characteristics:

> - Low educational attainment. 87% primary or no formal education.
> - Unregistered businesses, 88%
> - Only 25% as members of trade or business associations
> - Most of the players have other occupations (80%) and therefore lack commitment to their primary trade or vocation.
> - A large majority earn very low incomes.

In local parlance we call them "bodwa bodwa"

We need now to look at the other component, i.e. the formal sector of the Private Sector. This consist of a host of multinational companies engaged in mining, construction, commerce, banking, telecommunication, plastics, drinkables including water refilteration, etc.

A large component is also made of State Enterprises in agriculture, manufacturing, financial services etc and a small group of Ghanaians in commerce, transport, some manufacturing and financial services.

A close analysis of the activities of this formal sector indicates that they have very few vertical and horizontal linkages. Most engage in secondly processing using imported raw materials e.g. paper, plastic granules, etc.

For instance large soft drink producers do not use local fruits; they use imported flavors and therefore have no link with local farmers. Consequently, the wealth they create tends to be concentrated within their own players. As a result of this there are huge disparities in earnings. Thus there are many cases where senior staff within such organizations may take in $1,000.00 or $2,000.00 or even

$3,000.00 monthly salary where their counter parts employees may take $100.00, $200.00 or $300.00.

They do not generally engage in original research into local materials.

A close examination (2008) of the educational profile of the players reveals that unlike South Korea where over 60% of the citizenry has higher education only 3% of Ghana's population has high—i.e. tertiary or university education.

Dear reader, this is the structure of the Private Sector. We can now evaluate its capacity to contribute to Poverty Reduction in the context of this economy.

POVERTY:

Distinguished reader, it will certainly be inappropriate to define poverty only in terms of incomes. There are many other indicators of poverty; the most obvious ones include access to safe water, reasonable clothing and shelter as well as nutritious food, health and education.

At this juncture, we need to draw a distinction between symptoms of poverty and naked poverty. My definition of naked poverty is inability to create more than what one needs to survive on i.e. including the needs of the nucleus family.

But let us remember that Poverty is also dynamic. The 'Stone Age Man' without what we may call formal education could survive on what he could extract from nature at that time. Unfortunately, the Stone Age man in view of the fact that poverty is dynamic may not survive in the 21st Century.

The Dynamics of Wealth Creation in the 21st Century

I wish to submit that in the 21st Century Wealth Creation, which is the antidote for Poverty Reduction/Eradication is governed by three major parameters—KNOWLEDGE, FINANCE AND TECHNOLOGY. Broadly these are defined as follows:

KNOWLEDGE: Covers dynamic information, total management skills inclusive of administrative, financial and marketing experience.

FINANCE: Refers to the availability of financial resources.

TECHONOLOGY: Includes scientific <u>know-how</u> and the means for executing both programmed and programmable activities inclusive of the use of tools, time, material and energy. Like knowledge, Technology is also dynamic.

I believe that unless this country is put on the "right" path of Technological Development it might simply not survive.

It is common knowledge that the categorization of nations into advanced/rich and developing/poor is merely an index of the nation's technological status (advanced, intermediate or poor).

History also teaches us that the former leading countries of the world, Greece, Portugal and Spain, lost their lead in the world power politics when they got stuck in commerce and trading while their counterparts—Britain, France and Germany invested in Industrialization and Technology.

It is now universally accepted that the greatest enemy to poverty is technology; i.e. the higher the technological base, the lower the poverty rate.

Unfortunately, Technological achievement does not occur by chance or through an aging process. It cannot, for instance, be likened to the growth of a moustache on the fore-nose of a young man or the beard on the chin in the transition from boyhood to adolescence nor can we equate it to the PUBERTY STAGE in a female at the transition into womanhood.

Technological achievement can only come through a **DELIBERATE EFFORT AND ACTION** just like **PREGNANCY.**

Like pregnancy we need to nurse technology to bear fruit to benefit mankind. Technology, like religion, is God's gift to ALL MANKIND. It is independent of language, colour of skin or nationality. We can only shake off our self-imposed poverty if we choose the path of technological development.

As an engineer with over 45years experience (2011), I am totally convinced that the non-application of science and technology in our developmental effort, by and large, is the main cause of our economic retardation. We need to go back and **DISCOVER, DEVELOP, MAXZIMISE AND DEPLOY OUR POTENTIAL HERE** (courtesy Dr. Otabil)

CHAPTER XI

ASSORTED MACHINE TOOLS, STEEL WORKS AND FOUNDARIES:

Ghana can build **immediately** at least 70% of all the machines required for our basic industries—food processing, wood processing, brick and tiles, ceramics, soap processing, just to mention a few, provided we can draw a programme to utilize all the idle machine tools inherited from the State Enterprises—railway engineering workshops, State Construction, State Transport, Food Production Corporation, Gratis, Institute of Industrial Research, Atomic Energy Workshop, etc.

My assertion emanates from the following premise—our technological base, i.e. machine tools, foundries, know-how at the present time is roughly equivalent to the position of Europe in the 1940s and 1950s if we discount the advantage of computer as well as opportunities provided by the internet for information gathering.

Let us therefore build those machines including the Spit Fire which Europe was building in those years, now. In which case, the **TECHNOLOGICAL GAP** will be reduced to 50 years. In my estimation, our inability to build those machines now puts the technological gap to over five hundred years.

This gap will increase and so will the **POVERTY GAP** until we start building our needed machinery and equipment.

The old Adam and Eve economic theory, courtesy my friend, Prof. Frimpong Boateng, of land, labour, capital etc. is no more tenable.

A major characteristic of the three powerful tools is that each can be sold and yet be simultaneously retained. We can sell knowledge while keeping it, sell technology while keeping it and sell money through what is described as giving financial guarantee without necessarily parting with the money. To create wealth we need to empower the players with the tools listed above.

I submit that if we do not evolve new national strategies to empower the Private Sector and also create a framework, for it to perform, it will never deliver.

MACHINE TOOL TECHNOLOGY CENTRE

The fact is that without a good Machine Tool Centre we cannot practicalize our innovative ideas. My friend Col. Jackson has conceptualized and even patented a lot of innovations that threaten to remain on file indefinitely because we lack the capacity to physically develop them due to the absence of a good Machine Tool Centre.

Now what is Machine Tool Centre? This consists of a facility equipped with advanced machine tools—computer-aided designing (CAD); computer aided manufacturing (CAM), computer numerical control (CNC) to facilitate fast and precision component machining and products; Soft-wares for reverse engineering, simulation to evaluate product reliability and accuracy are also incorporated in the system. To demonstrate the overwhelming advantage of CNC machine over conventional machine, I wish to call your attention to the following:

A master machinist can produce a gear in 4 hrs using a conventional machine tool. A CNC machine can produce the same in 4 ½ mins. Calculated in ration of efficiency it is 1:53. In other words for every gear produced on the conventional machine fifty three pieces would be produced by a CNC machine.

To replicate a gear like this all you need are the following:

a. A good sample gear
b. A digital camera
c. Unigraphics / solid works software
d. Appropriate steel material

CAD-CAM technology allows the design and manufacture of a precision-engineered part as the CAD application software tools generate 3D solid models and 2D drawings. The CAM application software tool verifies a virtual reality simulation of the machining process, whilst the verified NC-Code controls the operations of the CNC capable machine tool.

The Coordinate Measuring Machine "CMM" is used for reverse engineering and inspection of finished parts. The component is therefore accurately designed and machined, whilst scrap and machine tool collision is avoided.

The removal of much of the manual element in the design and manufacture of precision engineered parts significantly reduces the cost, errors, down time and wastage endemic amongst machine shops using more traditional methods and conventional metal cutting machine tools.

CAD tools will offer customers a bespoke design service such as 2D drawings or 3D solid models.

CAM tools will offer customers a sub-contract or bespoke engineering service. For example, NC-Code generated could be verified and/or simulated on "vericut" facility will allow shop to design cost effective spare part ranges for imported machinery tractors for example and also to repair and/or recondition most other engineering equipment—hydraulic cylinders for example.

Additionally such Centres will be equipped with advanced foundries and have facilities for physical and chemical testing, induction hardening and provision for testing flatness, roundness and angular accuracies.

India has two such facilities in Punjab and Bangalore. 70% of the establishment cost was borne by the UNIDO.

Since 2002, C.T.E.D. has been crusading on the need to use UN resources just as the Indian's did to put up a similar Centre in Ghana. We are sad to note that a UNIDO sponsored team has submitted feasibility studies to Government since 2005 with no result. I am also very happy to say that a group of highly spirited Ghanaians led by Prof. Kwabena Frimpong Boateng has set up a small facility in Tema to demonstrate the advantages of this kind of infrastructure in order to sensitize Government to understand and appreciate the importance of such equipment.

The availability of machine tool actually fulfills this need. In other words, this country cannot create wealth without an efficient tool.

This is the reason why the writer and C.T.E.D. (Centre for Technology Driven Economic Development) are advocating for the acquisition of advance Machine Tool Centre.

The establishment of an Advance Machine Tool will help solve the problem of lack of spare parts for our lifts and miscellaneous equipment used in the hospital, agriculture and industry as well as giving us capacity to replicate airplanes, helicopters, fire tenders, road making equipment and infact all the major industry equipment we need to help us overcome the poverty gap.

We have stated elsewhere that the poverty gap is a technology gap and there is no way this country can create sustainable wealth without the presence of an advance Machine Tool Centre. All the revenue made from our exports will be used to buy spare parts for our factories, oil refineries, hospitals, and equipment that we use in our daily lives.

GHANAIANS PLEASE WAKEUP!

From the UNIDO report, an advance Machine Tool Center will not cost more than $30,000,000.00 (thirty million dollars). We beg our readers to force the Government to implement the feasibility report on this subject submitted in 2005.

THE PARAMETERS OF VALUE ADDITION PROCESS:

It is known that any value-addition process has the following seven components: TIME, CAPITAL, ENERGY, TOOL, MATERIAL, INFORMATION and MAN POWER as an INPUT.

The OUTPUT of this process may serve as an INPUT for the next process. The output is evaluated on the following:

(1) Economic Gain, **(2)** Environmental Damage, **(3)** Customer convenience, **(4)** and Depletion of Natural Resources.

This goes through a feedback and adjusted as necessary and the process is repeated for the next value addition chain.

Readers must note the shortcomings of the strategies being adopted by both NPP and NDC which emphasize totally on capital or finance and ignore the other important components.

In fact as noted by Mats Kalson, a former head of the World Bank in Ghana in his presentation on GPRS II "The document does not have greater depth on a number of issues. For instance the issue of energy, though an important one that greatly affects the country in diverse ways receives very little attention." Mats Kalson further stated, "There are no clear linkages between the various sectors of the economy," adding that "Instead of clear results matrix, the document contains merely a policy matrix that is spread over 70 pages. This makes it difficult to identify the country's priorities as well as measure policy outcomes." He concluded by saying "Furthermore, the GPRS II does not have a financing plan. This omission makes it difficult to tell how much resources need be committed to different areas of the plan."

These shortcomings arise because unlike the CPP programme **(see CPP manifesto)** the GPRS II did not emanate from the National Development Planning Commission which would have used the comprehensive approach for National Development to prepare the document.

Our assertion was supported by "STRUCTURE OF PRESENTATION GPRS II"—PARAGRAPH 1.5 sub 3 PAGE 9 {2006-2009}).

QUOTE: "The GPRS II document is not designed to present a set of cut and dried policies and programmes. It rather represents a medium term framework which offers a platform for maximizing social dialogue with Civil Society and development partners in order

to arrive at the best long term solutions to National Development challenges."

Similarly, the NDC vision 2020 document did not quantify their "middle income." How can you achieve what you have not quantified?

It is unfortunate that as in previous years no serious attempt was made in this country to put up a meticulously drawn national development program with quantifiable targets under Kufours' presidency (2001-2008).

It must be admitted that, MR. J.H. Mensah, the head of the Economic Planning Commission, promised in his comment on GPRS II, he would put up a national development plan in 2009 but his Government, as we all know, could not win power.

So at this juncture, we appeal to any new government to start its activity with a clearly defined national development agenda or pragramme with quantifiable targets to ensure vertical and horizontal linkages between all the players within the economy.

Middle Income is governed by three dynamic parameters: TIME, INCOME, and POPULATION. How can anybody determine his position in a race involving two other people when you have no capacity to determine the speed of your competitors?

CHAPTER XII

THE WAY FORWARD:

First we need to make a paradigm shift in the structure of the economy. This means that this economy must move from reliance on agricultural and industrial raw materials to processed engineering goods and exportable services.

Secondly, we need to adopt the knowledge-based technology-driven economic strategy.

The knowledge-based strategy demands that we must have full information of the agricultural and industrial raw material data base and their potential uses, i.e. their value addition chain. Economists refer to this as the **INPUT/OUTPUT MATRIX.**

Using additional Social Statistical Information from appropriate institutions

SOCIAL / STATISTISCAL INFORMATION

BASIC DATA

(See Table 2 below and footnote on page 36)

[Table 2]

YEARS	POPULATION	ENERGY KW	POLICE	PURE WATER	NEW CLASS ROOMS	TEACHEARS	SOAP TONS/ MONTH
2010	24,223,431	4,844,686	48446	484468620	23254	23254	12111
2011	24,804,793	4,960,958	49609	496095860	23812	23812	12402
2012	25,400,108	5,080,021	50800	508002160	24384	24384	12700
2013	26,009,710	5,201,942	52019	520194200	24969	24969	13004
2014	26,633,943	5,326,788	53267	532678860	25568	25568	13316
2015	27,273,157	5,454,631	54546	545463140	26182	26182	13636
2016	27,927,712	5,585,542	55855	558554240	26810	26810	13963
2017	28,597,977	5,719,595	57195	571959540	27454	27454	14298
2018	29,284,328	5,856,865	58568	585686560	28112	28112	14642
2019	29,987,151	5,997,430	59974	599743020	28787	28787	14993
2020	30,706,842	6,141,368	61413	614136840	29478	29478	15353
2021	31,443,806	6,288,761	62887	628876120	30186	30186	15721
2022	32,198,457	6,439,691	64396	643969140	30910	30910	16099
2023	32,971,219	6,594,243	65942	659424380	31652	31652	16485
2024	33,762,528	6,752,505	67525	675250560	32412	32412	16881
2025	34,572,828	6,914,565	69145	691456560	33189	33189	17286
2026	34,402,575	6,880,515	68805	688051500	33026	33026	17201
2027	35,252,236	7,050,447	70504	705044720	33842	33842	17626
2028	36,098,289	7,219,657	72196	721965780	34654	34654	18049
2029	36,964,647	7,392,929	73929	739292940	35486	35486	18482

plus data on international trading activities from CEPS, **(see table 17 of Trade below)**

Table 17: CEPS Data-Base Imports of Goods into Ghana

HS Code	Product Description	Year 2000 CIF Import Value ($)	Year 2001 CIF Import Value ($)	Year 2002 CIF Import Value ($)	Year 2003 CIF Import Value ($)	Year 2004 CIF Import Value ($)	Total Avg % Growth (2001 - 04)
4001	Natural rubber, balata, chicle etc, prim form etc	0	7,921	67,300	17,152,029	43,167	76%
4002	Synth rubber 7 fabric, inc nat-syn mk, pr fm etc	0	33,674	140,828	415,137	102,646	45%
4003	Reclaimed rubber in primary forms or in plates, sheets or strip	0	10,307	9,468	68,229	6,489	-14%
4004	Waste of rub,exc had rub, & powder obtain thereof	0	20,563	23,004	24,397	5,131	-37%
4005	Compounded rubber, unvulcanized, primary forms etc	0	800,987	431,488	1,230,211	218,084	-35%
4006	Unvulc rubber forms nesoi & unvulc rubber articles	0	96,152	170,513	634,973	236,270	35%
4007	Vulcanized rubber thread and cord	0	17,838	13,165	98,827	34,673	25%
4008	Plates, sheets, profile shapes etc, soft vulc rubber	0	302,694	406,442	2,445,415	638,017	28%
4009	tubes, pipes & hoses of unhard vulcanized rubber	0	2,596,080	1,931,333	8,964,200	2,809,707	3%
4010	Conveyor or transmiss belts of vulcanized rubber	11,422,744	1,675,291	2,698,060	10,994,985	3,701,935	30%
4011	New pneumatic tires of rubber	0	29,413,940	32,138,299	216,526,588	43,903,327	14%
4012	Retread or used pneu tires, solid tires etc, rubber	0	8,057,953	6,523,719	38,499,438	8,443,361	2%
4013	Inner tubes for tires, of rubber	0	946,356	874,239	6,168,838	1,256,082	10%
4014	Hygienic or pharma articles of unhard vulcan rubber	0	1,473,689	2,267,866	4,237,159	1,075,313	-10%
4015	Art of apparel & access of unhard vulcanized rubber	0	556,466	663,164	3,023,806	617,685	4%
4016	Articles nesoi of un harded vulcanized rubber	0	3,067,066	2,467,150	13,980,985	4,070,473	10%
4017	Hard rubber in all forms: articles of hard rubber	0	101,701	59,238	326,265	113,897	4%
4201	Saddlery, harness, traces, leads etc, any material	0	14,829	21,157	209,996	166,343	124%
4202	Travel goods, handbags, wallets, jewelry cases etc	0	9,898,638	9,689,465	49,352,684	42,586,952	63%
4203	Articles of apparel & access, leather & comp leather	0	209,534	225,744	2,745,603	2,573,141	131%
4204	Articles of leather used in machinery/mechanical appliances	34,065	108,817	16,870	142,154	128,187	6%
4205	Articles of leather, nesoi	0	42,547	43,241	213,897	201,109	68%
4206	Articles of gut nesoi, of gold beater's skin etc	0	4,224	1,821	6,384	6,153	13%
5901	Textile Book covered fabric; tracing cloth; paint canvas	0	2,929	32,915	486,424	441,517	432%
5902	Tire cord fabric of high tenacity yarn, nylon etc	0	378,039	2,883	739,651	704,966	23%

58

we can draw a programme to strengthen and stabilize what we call the old economy and **DECLARE NEW OBJECTIVES** in consonance with the NEW WORLD **ECONOMIC ORDER— IT** (INFORMATION TECHNOLOGY), **BIOTECHNOLOGY** and **NANOTECHNOLOGY** (It deals with particle size below or

equals—One Billionth of a meter) to be sure we are not left behind the technological race.

The MATRIX referred to earlier will show the vertical and horizontal linkages as well as strengths and weaknesses within the sectors. This will help us evaluate our energy needs, water requirement and determine corresponding economic infrastructure—i.e. transport and telecommunication as well as health and market centers among others.

For easy understanding of the process, let us call this matrix, the economic spreadsheet which in effect will serve as the ROAD MAP. It is only on this basis that we can produce any meaningful Manifesto—a path chosen only by the CPP.

From this Road Map we can declare our priorities and set our economic objectives with quantifiable targets from activities with multiple linkages.

It is only after this that we can identify the requisite PLAYERS to engage the enemy—POVERTY!

To win the war we need to empower the PLAYERS by equipping them with the three major tools—Knowledge, Finance and Technology.

It is obvious from above that the existing Private Sector has NO capacity to create wealth.

For accelerated and sustainable economic development we need a new Private Sector consisting mainly of the thousands of granduants' from Polytechnics and the Universities who are roaming the streets and queuing at the embassies for visas. In the language of the bankers this group is referred to as NON PERFORMING ASSET.

After prioritizing and declaring clear objectives for our National Development agenda, we will then upgrade our Scientific Institutes and possibly build additional Engineering Scientific Institutions to the status of Research Development Production and Training for them to act as Trainer of Trainees in order to empower the new players i.e. material from Polytechnics and Universities to become a Rocket Engine that will practically lift this country to the sky. This

is the way to create sustainable employment for the youth and solve the problem permanently.

Readers must certainly see the difference between the CPP approaches and that of the NDC/NPP. Simultaneously let us ask why the NDC and NPP did not adopt—this approach given the long years spent in power?

This new private sector will then link up with the informal sector of the old Private Sector which will enhance itself by buying products such as fan belts, clutch rubbers, organic chemicals and other miscellaneous goods from the new and prosperous Private Sector. In which case the street boys and girls would be selling goods produced by our economy. These goods would then go to the West African Market.

This is what the Koreans and the Chinese did and practically took the world by STORM

CHAPTER XIII

EDUCATION AND HUMAN RESOURCE DEVELOPMENT:

Dear reader, sometimes I hear people talk about Education and Human Resource Development. Then I ask myself—Education for what? Human Resource Development for what; If we do not define clear objectives with quantifiable targets, we cannot have a viable Human Resource Development Programme. Let us understand that Human Resource Development agenda cannot be static. In fact, they are very dynamic. Human Resource Development needs for the 1960s and 1990s and 21^{st} Century are different.

For a developing economy such as ours, we need to structure the Private Sector to act in consonance with clearly defined national objectives if it must be an engine of growth and thus contribute to Poverty Alleviation.

It is important to note that players of the Private Sector have one major objective—<u>TO MAKE MONEY</u>. In this regard, development if any, takes place in the <u>SHADOW</u> of Investors' or the Entrepreneurs' activities.

For Accelerated National Development and poverty alleviation the Private Sector must operate within a framework arrived at through meticulous planning by the State.

The Framework should consist of a series of Long Term, Medium Term and Short Term National Development Programmes subjected to periodic reviews dependent on global trends.

In setting up the 3 years National Development Programme 2001-2003 for South Korea, a team of specialists from Core

Ministries including the Korean Development Institute and a number of Research Institutions were put together to produce an action oriented Development Plan. The meticulously drawn plan listed 83 tasks spread over 5 selected areas:-

a. Information Infrastructure
b. Human Resource Development
c. Developing—Knowledge based industry
d. Science and Technology
e. Minimizing the Digital Divide

Dear reader, in 1998, South Korea had a deficit GDP of 6.7%. By the year 2000 it had achieved a growth position of 9%. We must not of course discount the fact that 1970–1980; South Korea had created a strong workforce of highly trained skilled artisans and craftsmen with the help of West Germany.

Sadly, this is what we failed to achieve when we could have taken advantage of Kofi Annan's tenure for the number of years as Secretary General of the United Nations. Noting that Kofi Annan had been the only person in the world who could talk directly to any world leader in his years as Secretary General, he would have been in a position to intervene on our behalf if we had drawn a programme for the training of a skilled workforce in countries such as China, India, Korea, etc.

It is imperative to remind ourselves that because of the truncation of our development process resulting in the precipitate collapse of our industries, especially GIHOC, Railway Location, Akasanoma Electronics, the Ceramics, Glass and other core industries, we lost our skilled workforce through the action of PNDC/NDC. The collapse of the industries did not allow gradual transfer of experience to another generation. Now we have a generation gap of over 30 years. Most of the earlier skilled workers are dead or in their 60s.

Ghana lost the **CARIOUS MOMENT** (refer to Otabil's preaching on Carious Moment) under both NDC and NPP.

To support the Wealth Creation Strategy the South Koreans in the year 1999-2001 established 10 new research and 12 new

Engineering Research Institutes to bring the number of their Scientific Research Institutes to 83 by the end of 2003.

Our Scientific Institutions are in permanent "Eclipse" under both NDC and NPP Government.

One also realizes that only one of the institutes, Industrial Research, deals with engineering research yet in the Korean programme mentioned earlier, out of the 22 Research Institutions built between 1999-2003 there were 10 Engineering Research Institutes.

Obviously the structure of our CSIR is not the best for accelerated economic development. Unfortunately, I do not have enough time to suggest changes because it will involve compressive study of the activities of all the institutions. However, in view of the importance of vegetable oil as a credible alternative for diesel fuel, I will, if I had power, expand the Oil Palm Research to cover all oil bearing seeds—i.e. Neem, Almond, Shea Butter, Para rubber, etc.

In addition to the establishment of a Machine Tool Center, if I had the power, I will immediately set up as a base for the chemical industry, Salt Research Institute and also a Rubber and Plastic Research Institute to take advantage of the 24,000 acre Rubber Plantation. Of course, information from my INPUT/OUTPUT Matrix after selection and prioritization of objectives will dictate my action plan. With the oil find, we must immediately set up a Petro-Chemical Institute to go into the value addition chain to spread the wealth base, to prevent the oil curse!

CHAPTER XIV

CRUDE OIL

DISCOVERY OF CRUDE OIL IN GHANA HOW TO HANDLE IT—THE APPROACH:

The U.S. is the biggest consumer crude oil at 24 barrels per capita. This is followed by Europe at 12 barrels per capita. China presently consumes 2 barrels per capita followed by India with 1 barrel per capita. The Chinese in effect want to live like the U.S. This will naturally result in higher consumption of energy. Presently the Chinese are abandoning the use of bicycles. In 2007 VW alone sold 1 million cars in China. If the Chinese increase their crude oil consumption to 4 barrels, the country will need 5.6 billion barrels, i.e. 1.4 billion x 4. The world had 800 million cars in 2007 and car population is increasing worldwide. It is obvious from above that the price of crude oil is not likely to come down drastically.

Ghana should therefore take maximum advantage of the newly discovered oil reserves to ensure that the product benefits the entire population; downstream value addition should be our first option. This will avoid the so called curse of crude oil. Many products can be derived from crude oil. The lists below are some of the major derivatives:

1. Rubber tires, Inks and Paints
2. Varnish and painters chemicals
3. Turpentine
4. Lubricating oil

5. Soaps
6. Gasoline
7. Diesel Fuels
8. Insecticides and Sprays
9. Cutting Paper, Leather and Textiles Oils
10. Rubber Compounds
11. Solvent Creams and Ointments and Petroleum Jelly
12. Anti Rust
13. Fuel and Metallurgical Coke
14. Fertilizers

The accompanying natural gas has 4 components:

- Methane
- Ethanol
- Propane
- Butane

All these have various uses. It is important to note that matters relating to crude oil cannot be resolved in isolation, i.e. outside National Development Agenda. For instance without the presence of an advanced Machine Tools Centre, giving capacity for machine building in Ghana, most of the ancillary services will have to be taken outside and Ghana would lose a lot of money.

CHAPTER XV

THE POTENTIAL OF AFRAM PLAINS AS A MAJOR WEALTH CREATING CENTRE

SUGGESTIONS FOR EXPLOITING THE PLAINS

Preamble:

The Afram Plains derive its name from the Afram River, a major tributary to the Volta River. The inhabitants are hard working peasant farmers growing miscellaneous crops—cereals, vegetables, roots and tubers under rainfed conditions despite the presence of a fresh water lake—one of the largest man-made in the world.

As said elsewhere in this book, the lake discharges 1000 tons of fresh water per second into the sea, when three turbines are working at Akosombo and 2000 tons of fresh water when all the six turbines are working. At a recent spill (2011), over 40,000 tons had to be discharged per second to save the hydropower plant. The land is fertile but the people are poor. Mechanized Land Clearing, seed bed preparation, planting and harvesting tools and equipment are absent. The hoe and cutlass are their main tools in the 21st Century.

In an interview with some inhabitants they claimed that God looks after them. Reliable roads, health centre's, good schools are very scarce.

Ghana is 54 years old and yet the "Barter" system exists in many places there.

When the rains fail, the farmers lose everything. When the rains come, they still lose because the middle men virtually pay very little for their products. But they have no alternative because they have no means to process nor store the harvest. The "Barter" is at its peak when the rains fail. In that case those near the lakes exchange their fish for food from their neighbors across the hills.

During the CPP time, VRA provided irrigation facilities for the settlers. Of course fuel was cheap in those days. The system is not sustainable now and therefore has been dismantled.

Some farmers use "Tomos"—(small petrol or diesel pumps) to beat the rains but margins are small.

Dear reader, please forgive me. I am charged with emotion, yes because 50 years (1961) ago I was studying engineering in the USSR after sixth form. At the time of writing this paper 2011, Ghana was 54 years old but we can't even build a simple Tomos engine with pump. Shame to our leaders!! Shame to Ghanaians for tolerating such leaders!! Yes because the Koreans created the enabling conditions for their engineers to manufacture their engineering goods and services.

Hitler created conditions for his engineers to build the Jet engine and the Intercontinental Ballistic Missiles. Yes the Engineer is a tool to be used by the State in a Developing Economy. The financial resources in this country are in the hands of the political elite. Let them take the right decisions.

Our proposal for the establishment of an advanced machine tool centre, given to government in 2005 has been sidelined.

Let me come back to my story.

The Afram Plains have deep top soil at certain places up to 12-15 inches or more. It is not possible for normal transport vehicles to traverse this kind of territory. Accessing farms and homes under such conditions create major challenges.

We also require cheap energy for production in addition to efficient transportation system.

The real potential of the Afram Plains:

Dear reader, some of us still believe that God is a Ghanaian. For this country is endowed with unique assets.

The Volta River lies in the middle of two mountain ranges—Automatic wind corridor! In addition to the wind map prepared by the Americans some Ghanaians have taken measurements of wind potential in the Volta River Basin. Wind speeds from 8 m/s to 15m/s exist. It is these wind storms that capsize the canoes. We need to exploit the potential for the benefit of the inhabitants. We need to break the reliance of the people on God's rain by the installation of wind powered pumps, the ones promoted by the late Major Quashiga, Agric-Minister in the NPP Regime. These machines were built here by the Agric Mechanization Division of the Ministry of Agric with FATECO, the Author's company. So there is local capacity.

We can also build large numbers of Wind Turbines for electric power production with proper arrangement with the Danish Government. We have modern fiber glass factories in Accra to build the towers and the blades. One to two mega watts power plants can be built and installed around the basin.

Elsewhere in this document, I stated that wind power is sustainable anytime the price of crude oil exceeded 60 dollars per barrel. The price of crude oil has persistently exceeded $70.00 dollars per barrel for the past 5 years, and is highly improbable that this price will go below $60.00 dollars. With cheap power for irrigation and cheap energy for processing of agricultural product nobody can underrate the level of wealth that can be created.

At the time of writing (July 2011) a Minister of State in Ghana had stated that Ghana can never wean itself from Donor support!

On Sunday 17th July on Joy FM morning devotion a pastor had talked about the "Tilting Point" and warned against statements from people that tend to dispirit a nation.

My dear reader, if the Koreans, the Malaysians and the Indians as well as the Vietnamese could wean themselves out of Donor

support why not Ghana? My plea is that Ghanaians must reject such people and with CONTEMPT!

Let me illustrate my point with only one example. The Afram plains have potential to produce large quantities of water melons. Dear reader, water melon has the shortest gestation period—only eight weeks from A-Z.

The plant has three major components, the sweet meal, the seed and the hard cork. The sweet meal is a source for juice and ethanol. The seed has oil for power if you wish and cake with over 38% protein for animal feed. The cork (the outer cover) is starch! With irrigation, the crop can be recycled at least five times in a year, giving room for land preparation etc.

We can enhance fish production by establishing fish ponds. The cake from the water melon seed can be used as feed material. We erect light from our "power" plants over the fish pound to attract large numbers of insects in the night. They fall into the ponds as they fly around the lamps supplementing the plant feed from water melons. I did not invent this. It is common practice in Australia!

Technologies are available in Ghana to produce sugar from the melons. The Author has discussed this with Prof. Debra of Food Science Dept. Legon. The water melon cork is starch which is food. Starch can also be converted to ethanol—another source for power, extra vegetable oil from the melons can be used to power the tractors, harvesters and other mobile equipment.

Transportation on the Afram plains is a major problem. We take inspiration in the saying that "If the mountains will not come to Mohammed, Mohammed will go to the Mountains."

Our solution to the Afram Plain transportation is if the soil is not suitable for existing transportations, then we need to create a transportation system to meet the challenges. Our position is that whatever we need to do to survive has been done by other people.

In years back when the then USSR embarked on full mechanization in wheat production in Ukraine, they had great difficulty in traversing the black Ukrainian soil. This gave birth to wide track combine harvesters that virtually floated on the soil. In fact, some of these large tracks combine harvesters were brought to

Ghana to harvest rice from Afife and Adidome which had similar conditions to the Ukrainian soils.

It is clear that for the next 100 years we will not be able to build roads in the Afram plains that will be suitable for orthodox vehicles. As a start we can enter into appropriate arrangement with Ukraine for the supply of full track vehicle chassis, with driver component high up to 15 feet on the chassis. We will then mount suitable bodies to carry produce from the plains.

Presently, there are half truck combine harvesters that have been designed with replaceable pneumatic tyres. The tyres are put on the vehicle when the ground is not too soft and they can be changed into tracks when the ground is very wet. Such a system can also be used as specialized vehicles for the Afram plain, e.g. a system that replaces the track with pneumatic tires—Kpong Farms (2011).

I had a good luck of seeing a half track combine harvester Deutz-Fahr incorporating a pneumatic tyre replacing system allowing the machine to work under all soil conditions—a perfect solution to the problem under discussion.

We have enclosed below pictures of the half track chassis and the large tyres used for converting the machine to suit soil conditions. In other words the solution for the problem of inaccessibility to farms during the heavy rain is right with us. We have no excuse for our inability to haul farm produce, including valuable cocoa, from farms and food depots anywhere in the country, be it the Western, the Ashanti, the Eastern or anywhere.

Half Track Chassis—Used when the ground is wet

Pneumatic Tyres replace the Half Track Chassis during off season when the ground is dry

I wish at this point to place on record that the Germans, specifically, West Germany was not producing half track combines before 1966. After the exit of the Soviets from Ghana after the over

throw of Dr. Nkrumah in 1966, the West became our "Developing Partners." The State Farms were compelled to bring in Class Combines from West Germany. Unfortunately, they could not cope with the clay soils of Afife where rice was being grown with aid of the Soviets. Class Combine went into half track combine harvesters after discussion led by me, the then Chief Engineer of the State Farm Corporation

We can equip the trucks with simple mechanized handling systems operated pneumatically from the vehicle's air compressor, or geared motor from the electrical system of the vehicle or from the hydraulic system. This will allow the changeover of the track to tires or from tires to tracks—it must be explained that these tracks and tires are very heavy and it needs a mechanized handling system to lift them.

Please do not crack your brains. This is not your problem; it is our problem (Engineers). Such machines will not have any problems traversing the plains.

Simple single axle tractors with half tracks will be supplied to the farmers. These vehicles can be made to run on vegetable oils or ethanol or bio diesel. Again the engineering details are our problem. I can also assure readers that it is totally possible to supply all the farmers with this kind of equipment within three years. The first step is to bring down from Europe front driven axles from used cars. The rest is easy. Build "Nika-Nika" engines and attach to the front axles with enlarged rims with suitable designs to allow them traverse the plains.

The reader may consult the statement on industrial policy elsewhere in this book to understand how to create great wealth from the plains. Yes we can!

Since we are in the 21st Century, we need to replace the pontoons on the lake with large capacity HOVERCRAFTS. These machines are not hi-tech; they can be built in Ghana.

Crusading Engineer Robert Woode

(See picture of simple Hovercrafts below)

http://www.bbvhovercraft.co

BBV -3 BBV -4

Leisure / Commercial Craft

BBV -4 BBV -5

BBV 6 & 8 seater craft

In fact, in the eighties, a young man by name Theodor Dwuvenuku, the son of Brigadier Dwuvenuku and a brother to a former Miss Ghana, built a working hovercraft that was demonstrated at the Trade Fair. He was also part of the team that was building a light air craft at Agbogba with Fateco Ltd in the 90s.

Powerful and reliable hovercrafts used to be deployed on the English Chanel, between France and Britain. They can carry huge loads at a very good speed. Hovercrafts ply in Sierra-Leone to lift people from the airport to the main land, so why not in Ghana?

HOUSING AT THE AFRAM PLAINS:

Most houses on the plains like most houses in rural Ghana are made of mud. During heavy rains they get soaked with water and collapse.

About 40 years ago one Ghanaian scientist, Dr. Mathew Teteh, fascinated by the fact that ant hills are water non-permeable, investigated and discovered the material that prevent anthills from collapsing under rain water. He managed to synthesize the resin, added it to soil and built houses with the material. Some of these houses can be found when you are entering Dansuman on the main Kanashie, Accra road. He was kidnapped by foreign agents outside Ghana and suffered great humiliation because he refused to disclose the material. The houses he built at Dansuman have been taken by Government and as at the time of writing (July 2011) he was fighting the matter in court.

We have a lot of natural fiber in Ghana—pineapple crowns, sisal, plantain and banana stems, kenaf, etc. This can be used to reinforce mud for building. Dr. Teteh's invention can be used to make the mud water non-permeable and save our rural huts! Where is the leadership to pursue this agenda? Dr. Teteh is in his seventies, and I hope we will not allow him to die without using his knowledge.

In the year 2011, we lost many talents. They include, Air Marshal Bruce, Squadon Leader Sowu, Capt Ampoma, all these were great pilots. I ask myself, why Ghana could not use these people including the Patengales, in an expanded programme at the Ghana Airways Training School to establish a Pilot School the same strategy Dr. Nkrumah adopted to establish the Medical School? Most of these great people have passed away apart from a few including Col. Abaka Jackson, and our "Boom Master" Papa J. The Afienya Gliding School set up by Dr. Nkrumah in the sixties

would have played a major role in such an establishment. Ghana would have had one of the best institutions for Pilot Training in Africa because we started very early. We even had first class female pilots, first in Africa in the sixties. This includes the mother of Dr. Angela Ofori Attah a former deputy Minister in the NPP regime as said earlier in this book.

Sorry for the deviation.

Lets us come back to the Afram plains. The increased food production from the irrigated fields will result in huge food by products and biomass for animal feeding:—cattle, sheep, goats, pigs, poultry including ostrich as well as the domestication of crocodiles and alligators—a common practice in South Africa and Zimbabwe. This will generate a huge value addition chain—Skins, (leather), food waste even for power production.

I need to end but not without commenting on the serious deforestation taking place there now. Apart from the north, the Afram plain is the biggest supplier of charcoal to the southern part of Ghana. What is happening there is a disaster in the making.

I must end by saying that no adhoc measures will be helpful. Let us draw a comprehensive plan with quantifiable targets. This will ensure proper horizontal and vertical linkage of the economy!

CHAPTER XVI

SALT AS AN IMPORTANT MINERAL RESOURCE FOR GHANA

Ghana's position in the Geo-ecological world map gives us a unique advantage in the West African sub region.

Ghana is sitting in an ecological wind path in West Africa. As a result of this, the country has relatively more wind than its immediate neighbors who have more rains. Weather records indicate that Benin and Nigeria on the Eastern side and (Ivory Coast) Cote de Voir and Liberia on the Western side have more rains than Ghana.

On the other hand the relative high wind facilitates salt production. Our neighbors are unable to produce salt because of this.

As a result of the rotation of the globe, rain clouds normally come from the East but are disturbed by the winds. The moisture laden winds regain their power after crossing our borders and deposit the rains in Cote de Voir (Ivory Coast).

Ghana must capitalize on this disguised blessing that gives us capacity to produce unlimited salt!

Salt is the basic material for the Chemical Industry of the world and is used in about 14,000 products. Nature does not give any country in Africa this advantage, except to a lesser extent Senegal.

All we need to do is to build the infrastructure and nature will do the rest. To take full advantage of this resource we must immediately set up a SALT RESEARCH INSTITUTE.

The institute must engage in Research and Development, Production and Training to ensure that practical knowledge is passed on to the students, who will link up with the Machine Tool Centre to replicate the necessary equipment for production. The whole activity must be linked to the National Development Programme to ensure horizontal and vertical linkages in the economic spread sheet.

Possibility of using wind turbines to pump brine (salt water) into various ponds or receptacles as well as the use of solar powered pumps must be looked into.

Wind turbines may also be used to drive crystallizers which may be installed in the ponds to accelerate salt production. As a first step let us give the project to the universities as "Thesis" subjects for students to work on. This is one of the surest ways to remove the self imposed poverty. <u>Yes we can</u>!

Our crude oil and gas may be limited, but our sea represents UNLIMITED RESOURCE!

Those with little minds need to understand that leaving such programmes in the hands of the so-called private sector will not see daylight. We are dealing with an undeveloped country. Our private sector has No Financial Power, No requisite knowledge, No Technology, therefore No capacity. Let them give me one example of any nation with similar economic characteristics that transferred itself into advancement by the power of Private Sector! This project can only succeed with the State in the Driving Seat to give necessary direction and empowerment.

CHAPTER XVII

THE PLASTIC INDUSTRY:

It is absolutely important to take full advantage of the recently discovered crude oil to reduce the poverty of our people because the biggest threat to our democracy, freedom and security is **poverty**. As we all agree that the solution to preventing the oil from becoming a curse is to embark on downstream processing to spread the wealth.

The plastic industry is a major outcome of crude oil and a deliberate effort must be made by the State to empower Ghanaians to get involved.

Reactivating the Aboso Glass Factory to produce glass fiber to reinforce plastic products will send this economy to the sky.

Reinforced plastic products have the following characteristics: light weight, high tensile strength, corrosion resistance, chemically inert, high heat and electrical as well as sound insulation resistance.

USES: Transportation, construction, civil engineering, marine, chemical and Electrical Engineering, and in allied fields. Tanker bodies, cargo containers, refrigerated containers, car bodies, helicopter rotors, boats, bath tubs, sinks, roofing sheets.

Industrial Items For Engineering Plastic—Coating media on wires (PVC Cables, flexible as well as others)—90% electrical parts and accessories, e.g. switches, plugs holders, pipes, fuss, etc.

CIVIL ENGINEERING: Plastic sheets as well as water proofing media, plastic panels, grills as partition walls.

ELECTRONIC: TV, Radio, Tape Recorders, Calculators, etc.

AERONAUTICAL ENGINEERING: Wings for helicopters.

AUTOMOBILES: Headlights covers, windscreen, car dash boards, various knobs.

HOUSEHOLDS: Plates, cups, sandals, shoes, bags, floor and wall tiles, etc.

MAIN PROCESSES: Extrusion, injection molding, blow molding, compression molding, transfer molding.

The above list strengthens the need to set up a Ghana Petrochemicals Industry/Research Institution. This should be part of our National Development Agenda within our SHORT TERM, MEDIUM TERM AND LONG TERM Programs.

CHAPTER XVIII

STATEMENT OF INDUSTRIAL POLICY:

The Indian Government in 1956 issued a resolution on Industrial Policy indicating the desirable pattern of industrial development in India.

It is obvious from Dr. Nkrumah's 7year development programme that Ghana's own programme took some lessons from the Indians.

Dr. Nkrumah was aware of the close interaction between agriculture and industry. The steel works in Tema and Takoradi, the Atomic Energy Workshop, the Adidome Workshop and the Industrial Machine Tool installed at the Tema Technical Institute were designed to provide important complimentary engineering inputs for agriculture and industry.

Highest priority was accorded to the generation and distribution of power that was the reason for embarking on the Bui Power Plant to support the Akosombo Power Station.

In addition to steel, cement was required for road and other infrastructure such as irrigation projects, so he set up the Cement Factory in Tema.

He believed in small and medium scale enterprises. Consequently a chain of these were established. These included, coconut fibre processing near Saltpond, cane and basket weaving factory in the Eastern Region, bamboo processing, glue, pencil and numerous others. We need to revisit them.

For the successful implementation of an SME programme we need to ensure that our yearly national budgets are linked to a clearly defined Industrialization Policy.

The policy should help us remove distortions in industrial activities, i.e. unhelpful tariffs, export of raw materials needed by local industries etc.

Effective decentralization of the Ministry of Trade and Industry should take place and must result in the establishment of District Industrial Centers which should conduct investigations (Input/output Matrix) in the districts raw materials and other resources, address the supply of machinery and equipment, credit facilities, marketing, and establish a cell for quality control, research and extension services by linking up with specialized institution—Standard Board, CSIR, Food and Drugs Board, Gratis, Export Promotion and Marketing Institutions, Investment Banks and Financial Intuitions.

Measures such as purchase preference and reservation for enclosure purchase by Government Departments and Public Sector undertakings must be used to support the marketing of the products from the SMES.

For accelerated industrialization of this economy, the State may have to be extra proactive. For instance selection of items to be manufactured must be the prime and forecast task for any entrepreneurs. And so it is necessary for every entrepreneur to make a careful study of market trends, people's changing attitudes competition and the like, raw material availability, power supply, changes in technologies, economic feasibility, before any investment.

Typical project feasibility cum market survey report must include the following:

1. Product Introduction
2. Properties
3. Standard Specifications
4. Uses and Application
5. Market survey, trend of market, future demand
6. Process of manufacture
7. Flow sheet
8. Viable capacity of plant
9. Machinery and equipment with their estimated cost

10. Total fixed capital requirement
11. Annual requirement
12. Annual wage bill of labor and staff
13. Working capital requirement
14. Total capital investment
15. Production cost
16. Profitability analysis
17. Address of manufacturers and suppliers of raw materials
18. Sources of procurement of equipment, Plant and Machinery etc.

FACTORY ACCOMODATION:

Absence of suitable factory accommodation is one of the main handicaps of S.M.E (Small and Medium Enterprises). Establishment of industrial estates in urban, semi-urban and rural areas will serve as great incentive for accelerated industrialization of the country.

Problems with sanitation and irresponsible disposal of wastes will not arise if such industrial estates are established. This will also facilitate registration of businesses.

PROJECT FINANCING:

Non-availability of credit on easy terms is one of the major handicaps of SMES. We need to fine-tune the process to cover long term (for fixed assets), buildings, equipment, etc. and short term—cash credit for staff, raw materials etc.

TRAINING FACILITIES:

We need to build entrepreneurship ability by creating an army of skilled and trained workers for the SMES. The Indians did this by appointing a Development Commission.

Service Institutes and Production/Extension Centres were established to take on board fresh students as well as persons already working in small industries. The objective is to tell them about new

equipments, tools and current technologies in their respective fields and help them improve their technical and managerial skills also.

Special courses must be organized in the following:

1. Financial Management and Cost Accounting, to cover financial management, financial accounting, cost accounting, financial and cost analysis and budgetary control.

2. Production Management to cover planning, organizing, standardization, simplification, purchasing, store keeping and inventory control and work study.

3. Marketing Management should cover distribution, management, and sales/salesmanship, market analysis, pricing, publicity, advertisement and export marketing.

TECHNICAL TRAINING:

To take on the world by Tsunami, we need also to conduct regular and adhoc training courses in various fields in the area of current technologies (I.T., Bio Technology, Nano Technology, etc.) because our starting point should be the end point of advanced technologies. This should form the basis of our industrialization policy.

CHAPTER XIX

THE INDIAN STRATEGY:

India's planning derived its objectives and social **premises** from the Directive Principles of State Policy enshrined in their Constitution. A planning Commission was set up in 1950 to prepare the blueprint of development taking an overall view of the need and resources of the country.

In consonance with the trend in those years, economic planning envisaged a growing public sector with massive investment in the basic and heavy industries.

The First Plan covered the years 1951–56, the Second Plan 1956–61, the Third Plan 1961–66.

This plan went through serious implementation difficulties necessitating the introduction of an Interim Plan along the line. The 4th Plan had to start in 1969 an end in 1974.

The Fifth Plan 1974–79 was originally drawn as part of a long term PERSPECTIVE PLAN covering a period of 10 years from 1985–95.

The PERSPECTIVE PLAN attempted to co-ordinate various sectors of the economy under a new slogan. **"GARIBI HATAO"** (Remove Poverty).

You realize that while the Indian programme was aimed at Removing Poverty ours was only to reduce it.

This Plan also went through some difficulties and was turned into a ROLLING PLAN which meant that every year the performance of the plan was assessed and modified as necessary.

The Fifth Plan was followed by three other plans, i.e. 6th Plan 1980–81, 1984–85. The 7th Plan 1985–90 and finally the 8th

Plan 1992–99 by which time the economy had become totally transformed.

The lesson is that this country needs a series of meticulously drawn plans to come out of our difficulties. Yes we need to __PROGRAMME OURSELVES__ out of our economic malaise.

As typical Africans, we try to resolve our problems by virtually explaining them away. But this is the time to __CONFRONT THE PROBLEMS__ with the sole aim of solving them.

Dear reader, for every 10 seconds you spend reading this paper, water equivalent to 20 million sachets goes from the Volta River into the sea. This water channeled for irrigation would have produced 31,104,000 tons (thirty one million one hundred and four thousand) tons of grain in a year, i.e. with 3 turbines working.

6 Turbines working at Akosombo would produce in a year 9,295 grams of grain for every inhabitant of the world at a population of 6.7 billion, i.e. 9 kilogram's, 295 grams of grain. This is how God has blessed this land. But Accra is also receiving 60 truckloads of charcoal every 24hrs at Ofankor barrier. This gives you an idea about the rate of deforestation taking place in Ghana.

Dear reader, human beings are being killed in Ghana because of mere mobile phones. Why, because for many people the balance between the physical/material and spiritual/morale has been broken.

Ghana can achieve $10,000 per capital if we can produce 30 million tons of vegetable oil only from about 7 million hectares of almond plantation. This can be achieved by mass participation of the youth. Let us note that the 22,000 acre Rubber Plantation in the Western Region was done by about 600 people in 4 years during Dr. Nkrumah's Regime. 2 million youth nationwide can do 7 million hectors in one month.

Details of the suggested programme are as follows:

CHAPTER XX

THE ALMOND AS A WEALTH CREATOR 3RD WORLD TO 1ST WORLD BY ONE TOUCH

Many countries have prospered on defined wealth base—crude oil, oil palm rubber, copra, sugar cane, cocoa, etc.

For the past 40 years Ghana has been living on a dwindling wealth base if we relate this to population growth.

The choice of Tropical Almond as an additional and major wealth base emanates from the following:

1. The rise in crude oil price is exerting great pressure on vegetable oil prices, because vegetable oil has very similar properties to crude oil.

2. Almond has a short gestation period and a good yield approximately 3550 kg/ha as against 2500 kg/ha for local palm oil. It must be admitted this is lower than to average in Malaysia.

3. Almond starts production in 2 ½ years, and peaks at 5 years while in Ghana real income from palm oil is after 8-10 years compelling farmers to go into pre-mature tree felling for palm wine.

4. Almond is a great suppressor of weeds. Harvesting is much easier than oil palm. Processing is much easier and requires less capital for the establishment of processing plants.

5. Rainfall requirement is much less—average 32-35 inches as against 60 inches for palm and therefore can virtually be grown everywhere in Ghana

6. Almond oil has a much higher price on the international market. A litter costs $10 to $12 ($10,000 to $12,000 per ton). Until recently palm oil price has been hovering around $400-$500 per ton. Presently, it has shot to 800 Euro or about $1200 per ton (April-May 2008).

7. Almond has a high protein cake at 42%. This is a very important characteristic since it can be used to replace/complement Soya bean cake as the main protein base for the poultry industry. Our fish farms will greatly benefit from the use of almond cake combined with extracted cocoa pod as feed material.

8. A strong poultry and fish farming industry will provide extra energy for the economy because both poultry fat and fish oil can be used to generate electricity. In addition, poultry litter can be used for biogas. The poultry industry is in crisis purely because of high feed cost. With cheap protein in price and volume, the whole Volta Lake can be turned into the largest fish pond in the world, giving rise to multiple industries processing of feathers, bones, oil, etc.

Planting over 7 million hectares will create a huge new forest if established in the catchment area of the Volta and help build the Lake to its full potential of 4,300 MW as against present capacity of 2000 MW.

9. Biomass from almond is equivalent to 60% of its dry weight—a huge material for power generation by first gasifying the biomass. One kilo of biomass produces 1 kw/hr of electricity.

10. Jatropha absorbs about 35 tons of co^2 (carbon-dioxide)/ha. On the basis of size, almond is estimated to absorb about 100 tons of co^2/ha and thus has good carbon credit.

11. Deficit cost to the environment from co^2 pollution is about $85.00 per ton.

STRATEGY FOR PLANTING:

a. Use mass mobilization of the population as work force for planting, initially for collection of planting materials.

b. Use Crop Research Institute to multiply seeds through Tissue culture for quick multiplication of seeds.

c. Use 22,000 polling stations as collection and redistribution centers for seeds to be nursed in individual homes. This must be done through programmes that whip enthusiasm for the whole idea.

d. Use **G.P.S.** for assessing digital map of Ghana from GOOGLE, identify suitable areas, and draw base line for lining and pegging parallel to the Equator to take advantage of rotation of the globe to facilitate power generation from wind turbines from wind corridors generated by the planting system. Estimated power from this source—2000 MW. It is important to note that the globe is rotating at 6,000 miles an hour and it's orbiting around the sun at about 67,000 miles per hour. That is why planting parallel to the equator would generate wind corridors which can be taken advantage of by countries close to the Equator.

e. Use National Service Personal and Army as base players.

f. Mobilize 2 million youth 200,000 per Region each to plant 32 trees in 8 hours a day or 1280 million trees in 20 days. At 175 trees per hectare total area equivalent to 7,314,285.7 hectare will be planted.

REVENUE:

1. Oil yield per hectare = 3,550 kg or 25,965,714 or approximately 26 million tons for whole area.

2. Inter-crop with Kroboko—a climbing plant with high oil material for ethanol and seed cake 30% protein minimum oil equivalent 4 mill tons. Total oil 30 million tons x $10 per litter = 300 billion **US Dollars.**

3. Cake yield is approximately 30 mill tons x $400 per tons equivalent $12 billion.

4. Biomass 60% represents 90 million tons of electricity in KW hrs. at 10cents per KW/hr = $9 billion.

GRAND TOTAL:

- Oil *** *** *** $300 billion
- Cake *** *** *** $ 12 billion
- Energy (Biomass) *** $ 9 billion
- CO^2 at $10 ton/ha *** $ 70 million
- *** $321 billion 70 million

Population at 2015 *** 29.4 million
Min per Capita *** $10,000.00
Immediate employment 2 workers/ha = 14 million Youth.

Subsequent employment from value additional chain:

- ❖ Cracking Nuts, Toasting Kernels
- ❖ Extracting Oil, Processing Oils, Cakes, Biomass at least 500,000
- ❖ Generate multiple Research Institutions to support programme
- ❖ Base for Transformation 3rd World to 1st World by One Touch

Ghana Go!

FINANCING: Create Special Bond. Open to international participation, open to Ghanaians in Diaspora.

LAND: Ghana has 28.7 million hectares only 23% cultivated. Capture power use it to pursue programme.

NOTE:
6 mill tons of oil can produce 4000 MW of electricity, through decentralized one MW modified Scania Diesel Electric Plants.

Vegetable oil from Ghana is being shipped for power production in Germany. One does not need to convert the oil into Biodiesel before being used. Appropriate modification can be made for Aboadze and similar plants to fire on vegetables oil to save high gas oil cost and bring price of electricity down.

Vegetable oil can be converted into Biodiesel—**See Article of 2001**.

Ghana can generate 10,000 MW from combined sources—vegetable oil, biomass, wind, fish and poultry, oil and fats and litter by 2018.

CHAPTER XXI

ALL HANDS ON DECK:

The expectations of our people are too great for comfort. We need therefore to embark on a programme that will compel all hands to be on board. Our situation can be summarized as follows:

The **BUS** called Ghana, conveying the Citizenry of this country suddenly stalls on a chequered road. We realize that the starter has failed. Meanwhile a mile away we see a raging bush fire that is likely to engulf us if we just sat arguing who to blame for our predicament. Our only solution is to get down from the bus and push start. If we can do that, we can stabilize the economy, in my view, within a short time.

We have **ONE** and **ONLY ONE** problem, i.e. **WE ARE NOT PRODUCING ENOUGH**, and in other words we are consuming more than we are producing. Let us appreciate the wisdom in the Akan Adage, **"Yente Aduro, Ene Ahahan"** (the herb is the basis of all medicine). This is the reason why the cedi has devalued from 1 cedi to a dollar during Dr. Kwame Nkrumah's time to 15,000 cedis (old cedis) now, i.e. 2011.

Around the same period during Nkrumah's time, the Japanese Yen was over 300 to a dollar, presently 2011; it is 80 yen to a dollar. This is rarely a mark of a Nation that is progressing and not ours. I'm totally amazed when I hear people say that Ghana is moving forward! It is only little minds who will claim that we are moving forward.

Crusading Engineer Robert Woode

(See Bio-Diesel Scanned below)

The Accra Mail, Thursday, February 22, 2001

accMAIL Mail Bag
Bio-diesel

Dear Editor,

I received the article on bio-diesel from a friend and I would like to inform you about my interest and motivation concerning the subject of BIODIESEL.

I am German and have developed a modification to run any diesel engine on plant oil: soya, sunflower, and others.

At the moment, I run my car with the used oil of my Chinese neighbour, who has a take-away restaurant. The oil is free of charge of course, and he is also saving money... because he has no cost to pay for recycling or disposal!!!

The standard Mercedes-Benz 200 diesel, 1986 model which I bought in November 99 presently has a mileage of 230,000km. The transformation was implanted at 160,000km, that makes a total of 70,000km in one year! running exclusively on "plant oil".

There has been no loss of power, no soot, no sulphuric acids or any other polluting ingredients. Only carbon dioxide - and that comes from a natural circle and goes back there. The smell seems strange at the beginning, but one gets used to it very quickly.

There is no danger for the population or environment as in vehicles or engines powered by hydrogen or gas.

I would very much like to get in touch with the author of the above mentioned article to discuss matters more in detail. Mr. Woode, as well as FATECO would also be an interesting contact. Hopefully, there is somebody out there in the never ending space of the web, who is interested in my system. The great car-manufacturers (European and American) are presently not very keen on the subject because of various reasons in no relation whatsoever to ecology and human health and welfare.

Please forward my concern as far as possible. Any correspondence in English, French, Deutsche will be answered immediately.

For contact and for any further information:

heartbeatprojekt@web.de

or phone: 0033/478948479, Holger A. Hauser, 8, Rue Jubin Villeurbanne 69100, France

CHAPTER XXII

<u>YES WE CAN!</u>

Dear reader, I beg you to remember that all human beings have one head, two hands, two legs, a pair of eyes and ears. This is irrespective of your nationality, colour of skin, language or whatever. We as Ghanaians can therefore have for ourselves whatever others, be it Americans, Russians, English, etc. have managed to acquire for themselves.

Our former President Dr. Kwame Nkrumah said, "Organization decides everything."

But we need to wake up and decide our destiny.

Ghana celebrated the 50th Anniversary of the Volta River Authority in the year 2011. In other words, we ran and maintained the Akosombo Hydropower Plant for nearly two generations! Simultaneously we have had an advanced Engineering University—KNUST for 60 years.

Can anyone therefore justify our inability to build the Bui Dam which is about one quarter the size of the Akosombo Plant? Can anyone explain why Ghanaians even don't seem to bother about this obvious anomaly?

Again in the fifties a ton of cocoa was sold for £2000.00(pounds). A VW car in those days cost £500.00(pounds), in other words; one ton of cocoa could buy 4 VW cars. The price of one ton of cocoa in the year 2011 is about $3000.00 or £2000 (pounds) i.e. the same price as was in the fifties. In other words, one requires 10 tons of cocoa to buy the same VW. The problem again is that Ghanaians seem not to bother. It only means one thing—<u>we are asleep!</u>

Nearly fifty years ago, we had the largest dry dock (over 100,000 tons) in Africa. Around the same period we had the petroleum refinery and the boat yards, yet we could not build the necessary capacity to make it possible for us to build the FPSO-Kwame Nkrumah. The FPSO is a floating production, storage and off loading vessel, a major facility in the entire crude oil production, berthed at the Jubilee Field near Takoradi.

Nearly fifty years ago, Ghana had the Golden Oil Meal –Gihoc Groundnut Plant) at Tamale and also the Essiama Coconut Oil Factory. This is the basic plant required for processing all oil bearing seeds apart from palm fruit. Yet in 2011, Ghana had to import Shea Butter processing plants because for 50 years we have not learnt how to replicate the earlier plants. This list goes on.

The tragedy is that Ghanaians seem not to bother.

50 years ago (1961) the Author was studying Engineering in the USSR and because we had entered the country after 6^{th} form in those days, the Chinese, the Cubans, and the Iraqis, etc could not match us. We totally outperformed them.

My heart bleeds and I frequently weep as I see these countries overtaking us and especially as we go to beg them for pittances.

It's all because the political leadership has refused to be in the driving seat as the Indians, Koreans, and Malaysians did.

Since the overthrow of Dr. Kwame Nkrumah, we have tried to run this country as if it is already DEVELOPED!

We still refuse to accept that in the 21^{st} Century, wealth creation is governed by FINANCIAL POWER, TECHNOLOGY, AND KNOWLEDGE, in combination.

The question is; does the ordinary Ghanaian have this? (Combination of Knowledge, financial power and technology?)

The Chinese did exactly what Kwame Nkrumah was doing to bring them to this stage. Using State Power to empower the citizenry to build knowledge, technology and financial power and subsequently allowing their God given talents to do the rest.

Can we imagine what would happen in this country if the ordinary plantain farmer had extra knowledge to extract fibre from the plantain stem, weave into colorful bags, or the artisanal

palm oil processor extract palm fibre for card board production or shred the empty bunch and produce rope, and the pineapple farmer also extracting fibre from the crowns, harvesting the roots of mature pineapples, slicing, drying and exporting to pharmaceutical companies outside? Or the tomato farmer fermenting his rotten tomatoes and using table top distillation plants to produce alcohol?, Or the cocoa farmer collecting the cocoa sweating for alcohol and processing the empty cocoa pot as feed for animals or preparing the material for potash extraction? Our famers have no knowledge on how to convert rotten food waste into various products including acids of various types and power through bio gas.

Without the capacity of our own people producing the needed equipment, we cannot reduce or eliminate poverty. The necessary capacity can only be built if we upgrade our scientific institutions in a Trainer-Trainee Programme in specific areas to empower our farmers to diversify their income. This is a responsibility of the State.

We complain about our roads, why? Because we cannot manufacture graders, bulldozers, compactors, asphalt layers, etc. These are no high tech machines!

Our agriculture is not sustainable because we cannot build tractors, ploughs, planters, harvesters, processing machines which are also non high-tech, (these machines have been around us for over 100 years). We spill untreated human waste into the sea because we have no capacity to build the necessary machines.

<u>We need to take those decisions</u>!

I remember the problems South Korea had when it decided to established its steel infrastructure. The World Bank and its sister organizations refused to support General Park, who ignored them. We all know the result. I visited the plant in 1991, and was struck by the following: **"RESOURCES MAY BE LIMITED BUT RESOURCEFULLNESS IS UNLIMITED."**

We need to take <u>BOLD</u> decisions. Our detractors talk of lack of world market. This is a FALACY! If anybody can build a vehicle

cheaper, more reliable and safer than say the Mercedes Benz at say half the price, the Mercedes Benz Factory may be forced to close. And this applies to all engineering goods and services because of the global market.

When in 1927, Ford started producing its model T cars at the rate of 10 seconds per vehicle; it was thought that no country could march the Americans in car production. But what is the situation now?

Using existing technologies as our starting point, i.e. the end point of Europe, America and China and with the advantage of unlimited natural resources including water and sunshine and the most advanced tool—the computer, backed by a determined leadership, we can take on the world by **"TSUNAMI."**

It does not make sense to me why every village in France with an area many times larger than Ghana has had pipe borne water for over one hundred years now, and why Ghana with much more water resources cannot even supply the whole of its capital city Accra, with sufficient water after 54 years of independence.

Water filtration and distribution is a problem because of lack of engineering capacity. My CRUSADE is centered on above submission. This is what C.T.E.D stands for. We are appealing to all Ghanaians to support us. We are aware that there are many thousands of maybe other Ghanaians with better ideas. I urge them to talk. My Amusement Centre, Nkrumah Centenary Memorial Spot on the IPS Road Legon within Akapulko is available as an assembling point for brainstorming on all issues raised in this book or any other ideas that anybody may have. Our aims are to SENSITISE POLITICAL LEADERSHIP and turn the population up on the need to discuss issues that are relevant to the economic emancipation of our country.

We need to understand that oil, gold, diamonds and timber will concentrate wealth in a few hands and will create social problems as is happening in Britain now (2011), because the exploitation of the above listed resources requires heavy financial input which the ordinary person does not have. Britain has high per capita income, much higher than us but the problem is with the distribution of

wealth. Our people cannot live on LEAP. They must be empowered to create wealth in a sustainable way; a system that reduces the <u>CONTRADICTIONS</u> of the free enterprise.

The Chinese have shown the way. We need to study that and improve on what they have done. We need to create a system where the Elephant eats and the Ant also eats. The two coexist peacefully because the Elephant does not claim that because it is big it must have everything to the extent that it should consume even the little that the ant needs; nor should we have a situation where the Ants insist that they outnumber the elephants so they must have everything. We need a situation where the person on a bicycle is as happy as the person in a posh vehicle; a situation where a person drinking whisky or champagne does not feel superior to a person opting for a soft drink or even water. Let us remember that such situations did exist in the forties and fifties in this country.

It is important again to stress that every human being is at any time under two balanced forces;—Physical/Material and Moral/Spiritual. Our rational behaviors depend on this. This axiom was tested by the Germans during the Second World War.

History has it that a plate of sliced bread was placed before a number of very hungry prisoners of war with the strict instruction that any person who attempted to pick a loaf would be shot dead. As soon as the plate was placed on the table a group of people reached for the bread and were shot dead. This happened three times and on each occasion the people made the attempt and got shot. Why, because the balance between the physical/materials demands of the body and the moral/spiritual courage was broken.

A classical example of this was when our great Lord Jesus Christ on the cross shouted "Oh my God, my God, why have thou forsaken me?" The physical suffering was too much for his moral courage. I hope readers will not use this to justify stealing by public servants and politicians holding power on behalf of the people. As for some of those people, whatever we do there will still be some of whom Papa J will describe as GREEDY BASTARDS.

I must also assert that the absence of a clearly defined national development agenda with quantifiable targets makes it easy for

people to steal from the system. Running a country without a clearly defined program is like dancing high life, "anything goes." Let's see if we run the country as if Dancing WALTZ, which is well defined and clear. It's easy for anybody to point out if you go wrong.

I wish also to remind those politicians and civil and public servants who are exploiting the system to their personal benefits that, in addition to whatever you have you need BLESSINGS from the Good Lord. BLESSINGS will only come if we exercise great circumspection in our dealings with people that we are duty bound to serve.

We have earned very little from God Given Resources, timber from our forests, minerals from the earth, now oil and soon uranium.

Concurrently we are suffering from negative effects of this exploitation, all because we have no machine building capacity, i.e. for every 1 ounce of gold we produce under orthodox method, we use/pollute 8000 liters of water and the ratio of mercury is 3:1 and the water we pollute using the galamsay (un orthodox/artisanal method) method is far more than 8000 liter per ounce. Nobody has taken into account the cost of reversing this pollution. It could be immense.

The environmental cost for harvesting timber has been ignored by our people. Let us reverse this. The Koreans, the Indians, the Malaysians have all done it but why not Ghana?

News Flash—Aug. 25, 2011:

As I was writing, I just heard of the unceremonial dismissal of my friend Prof. Kwabena Frimpong Boateng from the Korlebu Cardio Center, a project he conceptualized, partially financed and practically solely implemented on behalf of his beloved country of Ghana. Apart from that, Prof. Kwabena Frimpong Boateng erected the biggest wall around Korlebu hospital, a feat that has not been done by anybody in this country. One would have thought that the Cardio Center could be described as a private/public initiative. He qualifies as a life chair person of the Center. We need to understand

that there is no precedence of this in the history of this country; definitely you cannot sack him using the orthodox public service regulation. This is a great disincentive for the people who might want to follow his footsteps. Sorry for this deviation.

At this point, let me pay tribute to my colleagues in C.T.E.D. Professor Kwabena Frimpong Boateng-secretary, Col. Jackson-treasurer, Dr. K.A. Owusu Ansah-member, Dr. Otabil of Central University—Spiritual Leader, and the late Onua Amoah of Blessed Memory.

Yes we can! For whatever we need to do have been done by others.

GOD BLESS GHANA!

CHAPTER XXIII

LEADERSHIP WITH SPECIAL ATTRIBUTES:

To achieve the above goals would require a leader with special attributes and qualities:

1. My leader must have a VISION of objectives. Remember Nkrumah's "Across the Parapet"
2. My leader must be ELOQUENT and ARTICULATE to express his ideas INTELLIGENTLY enough to persuade colleagues to appreciate and accept for implementation.
3. This Leader must be COURAGEOUS, COMMITED and STEADFAST so as not to WAVER unnecessarily once set on to POSITIVE COURSE—Positively stubborn but not obstinate!
4. Our leader must be transparently HONEST, SELFLESS and SINCERE but capable of discerning the thin lines between TRUTH, FLATTERY and FACTS, especially when he subjects himself to scrutiny.

5. The Leader must be SENSIBLE to appreciate that man's created economic resources are needed to balance mankind between physical requirements of the body and moral stability of the soul (Pragmatic, not Idealistic).

6. Apart from being a Team Player a leader must have capacity to INSPIRE others, for INSPIRATION gives hope and people imbued with hope can overcome great difficulties, over ride dangers and achieve great feats.

Finally, the Private Sector can make it and help alleviate poverty under a meticulously planned economy supported by ingenuity, endeavour and backed by an uncompromising determination to succeed.

> We must resist negative challenges STUBBORNLY.
> Our RESPONSE must be RAPID but FLEXIBLE.
> Ghana must take back its DIGNITY: A person without dignity can easily be subjected to abuse, can also be easily corrupted.
> We must never SURRENDER!
> Our DETERMINATION must be UNCOMPROMISING!
> Our RESOLVE must be RESOLUTE!

The Chinese took on the world by STORM. We <u>must take on the world by a TSUNAMI</u>!

The 1st step will be all Churches; Mosques must be supported to ensure that believers are made computer literate by the end of the 1st year using the facility of the religious body. Only the people who sincerely believe in Dr. Nkrumah philosophy will have the GUTS to do things like that!

Please be a <u>cell</u>, develop it into a TISSUE.

GROW IT INTO AN ORGAN KEEPING IN MIND, **GHANA FIRST**, EVERYTHING ELSE SECOND.

I pray that every one of you become a disciple of this doctrine and move this country out of its <u>SELF INPOSED POVERTY</u>.

R. WOODE
THE CRUSADING ENGINEER OF GHANA
0244-38-38-58
October 28, 2011

CHAPTER XXIV

Author Biography

Ing. Robert Woode graduated from the Ukrainian Academy of Agricultural Sciences in Kiev of the then USSR in 1966 with a MSc. Degree in Agricultural Engineering. He was recruited into the Public Service of Ghana by the Ministry of Agriculture and immediately seconded to the then State Farms Corporation where he quickly rose through the ranks from Assistant Engineer to Chief Engineer within four years displacing the expatriate chief engineer

who was so overwhelmed by the performance of Engineer Woode that he was prepared to serve under him, Ing. Woode,

the then Minister for Agriculture, the late Dr. Kwame Safo Adu, refused the offer from the expatriate chief engineer, who was relieved of his post. Engineer Robert Woode became General Manager (Engineering) for the State Farms Corporation and later Managing Director of a sister organization Food Production Corporation. While at the State Farms he designed and built the first bulldozer track shoe dismantling machine (1968), foot pedal operated cassava greater and introduced many innovations in the repair and maintenance of miscellaneous agricultural implements and agro processing machinery.

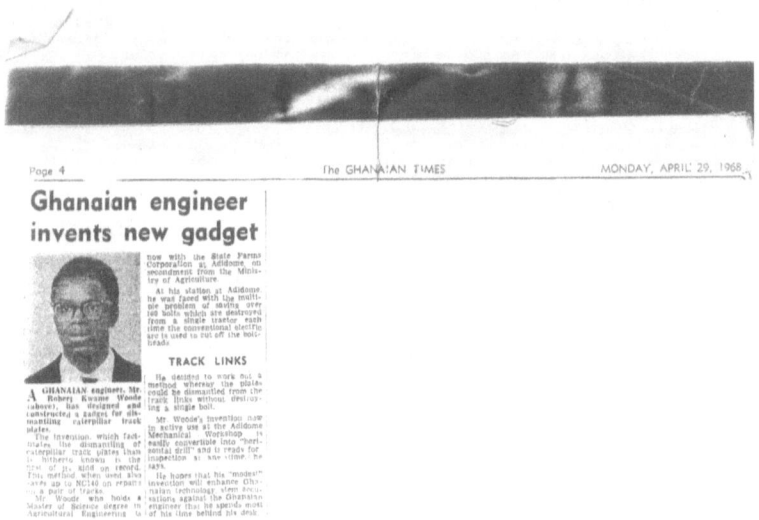

He served as the first President of the Ghana Agricultural Engineering Society (1971-72). He was commissioned to prepare a 400 page Engineering Standards Study Guide Book to be used by Africa Regional Centre for Engineering Design and Manufacturing (ARCEDEM) in Ibadan by UNDP in 1988.

In 1984 he set up a private machine shop for the manufacture of continuous presses for oils and juices. Ing. Robert Woode actually pioneered the manufacture of screw presses in West Africa. At the

recommendation of International Institute for Tropical Agriculture (IITA) Ibadan, many complete factories for vegetable oil extraction built by his company FATECO were sold in Nigeria. He has great interest in "Strategies" for Economic Development. He believes that Bio-diesel is a solution as an alternative for diesel in Ghana and is going all out to prove it.

(See Bio-Diesel Scanned below a rejoinder after writing a series of Article in the Accra Mail)

The Accra Mail, Thursday, February 22, 2001

accMAIL Mail Bag
Bio-diesel

Dear Editor,

I received the article on bio-diesel from a friend and I would like to inform you about my interest and motivation concerning the subject of BIODIESEL.

I am German and have developed a modification to run any diesel engine on plant oil: soya, sunflower, and others.

At the moment, I run my car with the used oil of my Chinese neighbour, who has a take-away restaurant. The oil is free of charge of course, and he is also saving money... because he has no cost to pay for recycling or disposal!!!

The standard Mercedes-Benz 200 diesel, 1986 model which I bought in November 99 presently has a mileage of 230,000km. The transformation was implanted at 160,000km, that makes a total of 70,000km in one year! running exclusively on "plant oil".

There has been no loss of power, no soot, no sulphuric acids or any other polluting ingredients. Only carbon dioxide - and that comes from a natural circle and goes back there. The smell seems strange at the beginning, but one gets used to it very quickly.

There is no danger for the population or environment as in vehicles or engines powered by hydrogen or gas.

I would very much like to get in touch with the author of the above mentioned article to discuss matters more in detail. Mr. Woode, as well as FATECO would also be an interesting contact. Hopefully, there is somebody out there in the never ending space of the web, who is interested in my system. The great car-manufacturers (European and American)are presently not very keen on the subject because of various reasons in no relation whatsoever to ecology and human health and welfare.

Please forward my concern as far as possible. Any correspondence in English, French, Deutsche will be answered immediately.

For contact and for any further information:

heartbeatprojekt@web.de

or phone:

0033/478948479, Holger A. Hauser, 8, Rue Jubin Villeurbanne 69100, France

He was a Management Board member of the Institute of Industrial Research for over 15 years as at 2003, i.e. longer than any other person in the history of the organization. He also served as Board member for Electricity Corporation of Ghana and Juapong Textiles,—Ghana Government/Lever Brothers joint project.

Ing. Woode has taken part in all major seminars organized by the Energy Commission of Ghana on Bio fuels. He was among the selected few who took part in the workshop on Bio fuels. R & D and technologies for sustainable development in Africa held in Accra from 11-13th December 2007 and organized by the International Centre for Science.

Subjects covered included:

1. Catalytic technology for production of bio fuels and fine chemicals
2. 2nd Generation of bio fuels. Challenges in technology.
3. Thermo-chemical conversion of biomass to bio fuels, etc.

Ing. Robert Woode is a Director/Secretary of Q.E.W. Ghana—a subsidiary of Q.E.W. Gmb H Germany, a company that specializes in the production of electricity from vegetable oils in Germany. Ing. Woode was appointed Chairman, Board of Directors CSIR—Oil Palm Research Institute in (2008).

He had his elementary school education at Kumasi Government Boys School, completing the then standard 7 middle school leaving certificate in 1953, continued at Accra Academy for School Certificate and finally at Adisadel College at Sixth Form before going to the Soviet Union in 1961 for his Master's Degree in Agricultural Engineering.

Because of his great interest in the 'strategies' for Economic Development, he was made the Chairman of C.T.E.D—centre for (knowledge-based) Technology Driven Economic Development. The group consists of eminent Ghanaians including Rev. Dr. Mensah Otabil of the Central University and founder of ICGC, Prof. Kwabena Frimpong Boateng, former CEO Korle-Bu and founder of the Korlebu cardio center, Dr. Kofi Amanor Owusu-Ansah, former member of the Council of State, Col. (retired) Abeka Jackson, a renowned scientist with Ing. R. Woode as Chairman. The principal objective of C.T.E.D was to sensitize government to adopt the knowledge-based Technology-Driven strategy for the development of Ghana. In this regard, members of C.T.E.D have been publishing numerous memoranda and giving many public lectures on relevant development issues thus earning the Special Award by Chartered Institute of Marketing Ghana (CIMG) in the year 2002.

Since his encounter with Dr. Kwame Nkrumah in 1948 when he was barely 11years old, the former had become his idol.

Ing. Woode has therefore established a spot "Nkrumah Centenary Amusement Spot," incorporating miscellaneous recreational machines including the largest ferries wheel in West Africa with the statue of Dr. Nkrumah mounted on the wheel some 50 feet in the sky. This statue rotates anti clockwise "asking" Ghana why are you going back? **(See back cover of the book)**, the first time in the world a rotating effigy has been mounted on top of a Ferris wheel.

The spot also has a photo museum showing some of Nkrumah's land mark projects. It is worthy to note that all the machines within the spot are designed and manufactured by the writer's company, FATECO LTD.

Ing. Woode is upgrading recently designed equipment that can climb any palm tree (date palm, coconut, oil palm, etc). The machine will be permanently exhibited at the spot when completed.

(See picture of designed Palm/Pole Climbing Machine below)

This equipment has a potential of opening a new design for lifts in already built homes.

It is hoped that the spot will improve the spirit of adventure in our people, remove fear of heights, make our people more daring, whip up their alertness and concentration and in-short make them better candidates for the race to space just like their counterparts elsewhere who take these things for granted.

Among the machines is a ROTATING SWING christened C.T.E.D. The swing is designed to simulate the "Yere Sesamu" sign. The significance of this equipment is that it stresses the need to change the structure of Ghana's Economy from reliance on Agricultural and Industrial Raw Materials to processed engineering goods and services—Thus the need for the establishment of an advanced Machine Tool Centre to create machine building capacity for ourselves.

(Picture of rotating swing machine can be found amongst the Recreation Equipments above)

Ing. Woode is married with 5 children and four grand children at the time of writing (2011).

Nkrumah Centenary Amusement spot is housed within the premises of Akapulko which is owned by his enterprising wife Mrs. Juliana Woode.

PRACTICAL CONTRIBUTION TO WEALTH CREATION IN GHANA

The Author has absolute believe in self reliance as a result of this he purchased a used tractor, registration no. TV 194, from the Keta Local Council in 1966 at a price of 30cedis (old cedi) and started selling charcoal purchased from Manfi Kumasi (a village in the Volta Region) to Keta.

In those days, a net income of one cedi was being made which could pay for hiring two workers. In 1967, the Author and three other persons invested in sugar cane farming at Nkontrodu near Cape Coast in the Central Region to supply sugar cane to Komenda Sugar Factory. The farm site was compulsorily acquired by Government to make room for the establishment of prison quarters.

In 1969, the Author together with four other public servants obtained a loan of 9,000 cedis from Agric Development Bank (ADB) to establish an Oil Palm Farm at Adum Banso in the Western Region. The total area acquired was 10 sq. miles, with additional loan of 11,000 cedis the group planted up to 400 acres of oil palm. By 1975-76, this was the biggest private oil palm plantation in Ghana at the time. This land was also compulsorily acquired by Acheampong Government, as Ghana Government contribution to a joint venture Ghana Government / Unilever called B.O.P.P. (Banso Oil Palm Plantation). The Government paid a reasonable compensation for this act that allowed the group to pay ADB and allowed us to make some reasonable returns. Fortunately, an oil palm factory built by the group which was located at Adum Banso village fell outside the perimeter of the acquired land.

The Oil Palm Factory was built in 1974. In the same year a new group comprising of the Author and his friend, Mr. Alex Anim,

imported a palm kernel oil plant from Japan and went into palm kernel oil production to supply palm kernel oil for the manufacture of soap by indigenous Ghanaians. In the same year 1974, another new group comprising of the Author and two other Ghanaians established a farm at Agbogba with a German company by name Alplant.

At peak production in 1976, Flour Ltd., Our company, was exporting up to 120,000 flower cuttings (crisantomon) a week to Germany. This project collapsed during the civilian uprising against Acheampong Government in 1976; this period was characterized by power outages, airport closures, etc. that made it impossible to meet our contractual obligations with Europe.

After the collapse of the flower project, the Author and Mr. Alex Anim established a large vegetable farm including 10 acre Pepper Plantation, the largest in the country at that time at Agbogba. As a result of harvesting difficulty, followed by invasion of rats in the country the project also collapsed.

In 1980, a new group, Alex Anim and Robert Woode, established a pineapple farm with over one million pineapple suckers at Agbogba only to be confronted by the great drought and the accompanying wild fires that hit the country in 1981. The financial loss was great but we remained undaunted. We then went in to establish a 15 acre cocoanut plantation at Agbogba. We had learnt great lessons from farming arable crops. The arable farmer in Ghana has many enemies including: 1. Unreliable Weather 2. Rodents 3. Insects 4. Birds 5. Thieves 6. Diseases and finally 7. Uncertain markets 8. Pest, etc.

In 1984, I and my partner Mr. Alex Kwaku Anim, who had been my friend during 6 form period at Adisadel College in the fifties and with whom I've been working since 1969 at Adum Banso decided to go into engineering with the main idea of assisting young men in the design and manufacture of miscellaneous agricultural tools and equipment in consonance with my profession as an agricultural engineer.

We also went into fabrication of agriculture machine including, maize shellars, groundnut threshers and finally into continuous oil

presses using the experience acquired from the establishment of an oil mill at Adum Banso 10 years earlier.

In 1987 the Government of Ghana had encouraged the growing of soya bean in the Central Region but due to marketing difficulty the farmers went into crises. Meanwhile, our company had sold a complete soya bean plant to Nigeria on the recommendation of IITA (International Institute of Tropical Agriculture) who had sent a delegation from Ibadan to inspect our product at Agbogba and had helped us to sell our first plant at Ilorin in Nigeria.

We set up a soya bean factory built totally by ourselves at Pokuasi and started buying soya bean from Central Region. Unfortunately, as a result of the losses the Central Region Farmers had incurred earlier, they had lost interest in soya bean cultivation. No amount of persuasion could bring them back.

The Pokuasi Soya Bean Factory had been set up on the advice of the Ministry of Agriculture who had learnt about our capacity to build such plants. After series of meeting with the Ministry of Agriculture, the Tono Irrigation Company (ICOR), and FASCOM (Famers Services Company) were encouraged to cultivate soya bean. At peak processing in the early 90's, our factory at Pokuasi was processing three articulator loads of soya bean (30 ton each) from the North every week and we were supplying all the major feed mills in Ghana (Aferiwa farms, Sankofa, etc.) with soya bean cake. At that time the poultry industry in Ghana was booming. We produced large quantity of crude soya bean oil which had no market, so we finally decided to build a soya bean oil refinery which we did with the help of Industrial Research Institute (IRI of the CSIR). The Institute built a laboratory model and we developed our pilot refinery from this laboratory model. Earlier when we tried to buy a refinery from Japan, the price quoted was about one million U.S. dollars that is why we refused and decided to build the refinery ourselves. We believe Ghana must choose this path for national development. We must create the determination to build whatever we need.

About the same time 1995, we decided to go into water filtration. Hereto, we built our own filtration plant using ceramic filters.

Shortage of water at Madina and Adenta had virtually collapsed the factory.

The refinery at Pokuasi together with a biscuit factory established there had also collapsed as a result of power outages. Anytime the power went off the temperature of the oil rose and burnt the oil and the biscuit in the oven also got burnt because the conveyor in the oven had stopped.

In 1998, we went into fiber glass production for Fiber Glass Components—Sinks, Jacuzzis, Fiber Glass Boats, Water Tanks, etc. The factory is also experiencing difficulties because of power outages that cause the raisins and the material to solidify in the machines when power goes off. In any case we haven't given up yet.

The last business is the manufacture and exploitation of recreation equipment which was described elsewhere in this book. We believe that the absence of a National Development Agenda with quantifiable targets had made it impossible for us to link up with any clearly defined National Development Agenda that made it also impossible to attract the necessary attention.

Below are some of the pictures that give credence to our efforts to help in contributing to Wealth Creation in Ghana.

(Pictures can be found amongst the Recreation Equipments above)

OXYGEN PRODUCTIN PLANT:

In 1991, I together with my friends Mr. Alex Anim and George A. Ackah took minority share holding (40%) in the company Oxy Air. The plant was supplied by Air Sep of Buffalo in the United States. The estimated installation cost was very high. I therefore went to the company in the U.S. to understudy the design and manufacture of the plant. Within a week I had completely mastered the system and succeeded in single handedly installing the plant when it arrived in Accra. Furthermore, I trained one Ghanaian who now installs all Air Sep Plants in West Africa.

The American Team that arrived from Buffalo went back in the same plane that brought them, they only spent 1 hour to commission

the plant. Since then all Air Sep Plants that have been sold in Ghana had been maintained by Ghanaians, I can say with pride that Ghana is in the position to put together an Oxygen Plant if necessary now. I am referring to the "Pressure Swing Method"—creating conditions where oxygen can be separated from air and bottled.

Incidentally after running the plant in a factory building financed by us and situated at Agbogba, the majority holder decided to annex the company for him. He arranged for a crane, a low loader broke the factory wall and moved the plant away which was assembled on a steel chassis. This matter took 12 years at the Fast Track Court before we had a ruling in our favour. At this time, the money had lost its value and worth nothing. Our legal system needs serious reforms. Ironically the lawyer for the defendants died before the ruling.

1. Design and manufacture of Small Air Craft:

In 1990, Fateco linked up with a young man by name Theodor Dwuvenuku, who had earlier built and demonstrated a working HOVERCRAFT at one of the Trade Fairs in Ghana. Brigadier Dwuvenuku a retired Army Officer from the Ghana Army, the father of Theodor Dwuvenuku was staying a few houses away from my own house in the Accra Teacher Training College and the IPS enclave in Legon-Madina.

Theodor brought drawings that convinced us that we could manufacture small air crafts that could be used for spraying and also as ambulance for moving distressed patients provided small Air Strips. **(Please refer to picture of a small air strip at Kpong Farms, Akuse in the Volta Region, photo enclosed below)** are built at strategic places in Ghana.

Air Strip at Kpong Farms in the Volta Region

The design allowed the pilot to change the angle of the rotor blades to facilitate take offs. A VW engine was used in the initial test run. Unfortunately the required 8000 rpm could not be attained. We identified high speed motor cycle engines from accident motor cycles at the Police Maintenance Shop around the Airport and pleaded to be sold one but the request was declined. It must be noted that in those days high speed motor cycles were not available (500 cubic centimeter) in Ghana. We used silk material as cover for the wing super structure. Research indicated that parachute material was preferable. We applied for an old parachute from the Air force and this was also declined. We had no alternative but to abort the programme. The system for varying the angle of the blade is still available for anybody interested to inspect.

THIRD WORLD TO FIRST WORLD—BY ONE TOUCH

(See pictures below)

Calculated Take-Off Speed—70miles per hour. Design Cruising Height—600ft

2. Design and Manufacture of "Cassava In Gari Out" Automated Plant:

Around the same period (1988-1990), one Joseph Asamoah who later became one of the Youth Leaders of the N.P.P had approached us with a plan to build an automated Gari Machine on the principle: Cassava in—Gari Out.

The system comprised of the following: Pre fermented cassava was fed into a grater with automated pallet that pushed the cassava against a cylindrical greater mounted over a screw press for dehydrating the mashed cassava. The dehydrated meal entered a pulverizer and later into a horizontally mounted drum fryer incorporating a pallet stirrer that finally delivered the fried product into a mill.

G.B.C. TV under program "AGRIMAC" was invited to film the machine but refused to show it on T.V. because it was a commercial activity. It was shown on GTV news for a few second. We could not raise the one million cedis being demanded in those days (1988-90).

The machine was financed by Sasa Kawa of Japan who insisted that the fryer must be dismantled because the village women who were supposed to benefit from the invention would be made idle. Sasa Kawa had agreed to finance it because they thought it will reduce the drudgery of the Gari producers. The machine was demonstrated at one of the Trade Fairs in Ghana. Nigeria showed great interest in the project.

As a food machine we needed to build it in stainless steel, unfortunately, necessary funds could not be obtained. The corrosive nature of starch on mild steel reduced the life span of the equipment. Gear box, screw, fine mesh were later removed and used for other purposes.

In the same year, we produce drawings for a machine "MAIZE IN KENKEY OUT" and gave the drawing to the then KNUST who could not raise money to manufacture it.

3. Palm Tree / Pole Climbing Machine:

In 2001, I read a magazine published by PORIM (Palm Oil Research Institute of Malaysia) and was fascinated by a programme to mechanize the harvesting of palm fruit by using a tree climbing machine. When I became a board member of OPRI (Oil Palm Research Institute) I also learnt about the difficulties of the organization when collecting pollens from tall cocoa nut trees for seed raising purposes (cocoanut seedlings). I then decided to take part in the race for the design and manufacture of the Palm Tree / Pole Climbing Machine.

(See picture of the Pole Climbing Machine below: first of its design in the world)
Readers may check on this from the internet

In 2009, I learnt that the Malaysians had abandoned their research into the project but I continued. In early 2011 we conducted trials of our machine photo enclosed below. The special motors originally imported from Britain were too low in power and could not lift the equipment. As of the time of writing, a new set of motors from India were being imported. We strongly believe we will succeed in this endeavor. The Machine if successful will open a new chapter in the design of simple lifts that could be used in the already built homes.

This country needs to create research fund for private entrepreneurs engaged in miscellaneous research activities. I am aware of many good inventions by many Ghanaians which are lying in shelves because they don't have access of funds to implement the idea. We hope that readers will take steps to sensitize Government on a need to create such a fund to help Ghana move forward.

IN PURSUITE OF JUSTICE

The Author Has Been Engaged in Many Human Rights Activities

Formation of SOTGA:

The main batch of Soviet Trained Doctors arrived in Ghana in 1968. They were subjected to humiliation and discrimination. The senior medical officers in charge of Korlebu alleged that the Soviet Trained Doctors were not up to the required standard; this is mainly because they were not used to the terminologies being used in medical practice in Ghana.

The Author together with others formed SOTGA (Soviet Trained Graduate Association) to fight for recognition of our certificates. The Author was elected as the first President of the Organization in 1968. SOTGA finally, through various activities, compelled Government to accept the certificates. The irony of the situation is that, most of these doctors who were alleged to be inferior finally set up their hospitals and virtually employed a lot of those senior doctors as part time staff. These hospitals include, Nabita Hospital as well as Dr. Caiko hospital also at Tema and many others.

Young Doctors like the late Dr. Bentsi who was among the three Doctors who perished some few years ago in an accident when returning from an assignment from Sunyani to Accra, was outstanding in his practice.

The second irony is that, all the Cuban Doctors who are presently manning health centers and hospitals in Ghana went

through the same course as the Soviet Trained Ghanaians. It must be remembered that Ghanaian doctors went into the Soviet Union before the Cuban came for their medical course in the early 60s. It is sad that even though we were ahead of the Cubans in this field we had allowed the Cubans to overtake us not only in medical practices but also in other professions including engineering.

SOTGA also played a major role in sending hundreds of Ghanaian student to the Soviet Union in the 70s for training in various professions. In the 70s as many as 100 Ghanaians were going to the Soviet Union on scholarships every year, i.e., when the Author became the President of the Ghana Soviet Friendship Society.

THE RETURN OF THE LATE SLAW'S SISTERS HOUSE AT KOKOMLEMLE:

During the time of the PNDC the house of Siaw's sister at Kokomlemle, not too far away from the present NDC Headquarters was confiscated by Government. Her son, Mr. Kwabena Darko of Oxy Air approached the Author who prepared series of petitions and mobilized the support of the press, specifically the VOICE for the de-confiscation of Kwabena Darko's mothers' house.

It was a very difficult exercise but I am proud to say that I played a major role to help the old lady take back her house.

THIRD WORLD TO FIRST WORLD—BY ONE TOUCH

Christened Ackah—Woode Ferris Wheel

1. Manufacturer—**FATECO LTD. ACCRA, GHANA**
2. Model—**FERRIS WHEEL WITH A REVOLVING EFFIGI ON TOP**
3. Availability—**TO BE FABRICATED ON REQUEST**
4. Seats—**16 SEATS OF 2 PER PASSENGER. TOTAL OF 32 ADULTS OR 48 CHILDREN**
5. Weight—**34 FT**
6. Power required—**2 GEARED MOTORS OF APPROXIMATELY MAXIMUM 5 KW EACH**

This equipment can be manufactured on demand by interested parties. Prices are way below international rates.

Christened C.T.E.D—in Honor of CTED members

1. Manufacturer—**FATECO LTD. ACCRA, GHANA**
2. Model—**ROTATING SWING / AMUSEMENT PARK RIDE**
3. Availability—**TO BE FABRICATED ON REQUEST**
4. Seats—**8 CAGES BY 2 PEOPLE, TOTAL 16 PASSENGER**
5. Weight—**5 TONS MAXIMUM**
6. Power required—**APPROXIMATELY 4 KW GEARED MOTORS**

This equipment can be manufactured on demand by interested parties. Prices are way below international rates.

THIRD WORLD TO FIRST WORLD—BY ONE TOUCH

Christened—Alex Kweku Anim

1. Manufacturer—**FATECO LTD. ACCRA, GHANA**
2. Model—**SPINNING WAGON / AMUSEMENT PARK RIDE**
3. Availability—**TO BE FABRICATED ON REQUEST**
4. Seats—**21 PASSENGERS**
5. Weight—**3 TONS**
6. Power required—**APPROXIMATELY 3 KW GEARED MOTOR**

This equipment can be manufactured on demand by interested parties. Prices are way below international rates.

Christened—Naana Woode, My Dearest Wife

1. Manufacturer—**FATECO LTD. ACCRA, GHANA**
2. Model—**SWINGING BOAT/AMUSEMENT PARK RIDE**
3. Availability—**TO BE FABRICATED ON REQUEST**
4. Seats—**12 PASSENGERS**
5. Weight—**3 TONS MAXIMUM**
6. Power required—**2 GEARED MOTORS IN TOTAL 4 KW COMBINED**

This equipment can be manufactured on demand by interested parties. Prices are way below international rates.

Single Sitter Fiber Glass High Speed Boat

This equipment can be manufactured on demand by interested parties. Prices are way below international rates.

Stainless Steel Juice Expeller with Strainer

This equipment can be manufactured on demand by interested parties. Prices are way below international rates.

Horizontal Sterilizer for Palm Bunches

This equipment can be manufactured on demand by interested parties. Prices are way below international rates.

Stainless Steel Industrial Blender

Continous Palm Oil Press

This equipment can be manufactured on demand by interested parties. Prices are way below international rates.

Miscelleneous Fiber Glass Products

This equipment can be manufactured on demand by interested parties. Prices are way below international rates.

Fiber Glass Mobile Toilet

This equipment can be manufactured on demand by interested parties. Prices are way below international rates.

Reference

1. The Future of the Youth for Science and Technology for Ghana by R.E.M. Entsua Mensah
2. The Ghana Young Pioneer Movement by M.N. Tetteh
3. Deep Down My Heart by K. Frimpong Boateng
4. Greatest Speeches of Historic Block Leaders (vol. 3) by Ben C. Anagwonye
5. Kwame Nkrumah Vision and Tragedy by David Rooney
6. High Technology Magazine vol. 4, no. Y
7. Science and Invention Encyclopedia, published by H.S. Stuttman Inc. 1987-1989
8. Manufacturing Technology, Today and Tomorrow, by Robert A. Daibe and Thomas L. Erekson
9. GPRS. I
10. GPRS. II
11. The History of Ghana Atomic Energy Commission 1963-2003
12. Hand Book of Rubber Chemicals and Rubber Goods Industries
13. Industries in India—P.K. Tripathi
14. State Farms Corporation Annual Report, July 1977—June 1978
15. UNIDO Final Report: Opportunity and Feasibility Study for the Technology Innovation, November 2005
16. Reference Book & Directory for Small Industries—V.K. Agg.
17. 834 Reserved Small, Cottage & Tiny Industries—SIRI Board
18. Hand Book of Rubber Chemicals & Rubber Goods Industries —Gupta & Dhingra
19. BBC—Science and Technology Programs
20. Online Research—Google

www.ingramcontent.com/pod-product-compliance
Lightning Source LLC
Chambersburg PA
CBHW032006170526
45157CB00002B/572